HIDDEN ART
IN NATURE

SYNCHROMIES

CREATED AND PRODUCED
by
EDITA LAUSANNE

OSCAR FOREL

HIDDEN ART IN NATURE

SYNCHROMIES

HARPER & ROW, Publishers
NEW YORK · EVANSTON · SAN FRANCISCO · LONDON

INTRODUCTION

by

PETER SCOTT

Oscar Forel, born in 1891, lives in an exquisite thirteenth century castle at St. Prex on the shores of the Lake of Geneva, three miles from the little town of Morges, itself only a few miles from Lausanne. The International Union for Conservation of Nature and the World Wildlife Fund have their Headquarters in Morges which has for four centuries been the home town of the famous Forel family. One of their houses in the main street is now the Musée Alexis Forel where the first Morges Manifesto which declared the responsibility of mankind for the conservation of the natural world and which led directly to the formation of the World Wildlife Fund was signed in April 1961; and it was here in 1971 that a plaque commemorating that event was unveiled by H.R.H. the Prince of the Netherlands in the courtyard of the museum.

Dr. Forel is well known in many fields of public life. Like his famous father, he has been deeply involved in psychiatric medicine and in social welfare. But Oscar Forel is best known of all for his Synchromies - his intimate photographs

of tree bark and wood which although a part of nature are transformed by his vision — his selection of composition and colour harmony and lighting — into superlative works of art. Jean Rostand writes delightfully in the preface about the synchomies which have evidently given him as much pleasure as they have given me. Exhibitions of them have been held in Paris, Darmstadt, Zurich, Lausanne, U.S.A. and Moscow, with great success and critical acclaim,

Nature has been an essential inspiration for art, ever since the first quarry animals were drawn on the roof of a cave. Painters down the ages have made their own translations from nature - in greater or lesser detail, with greater or lesser freedom and with happier or less happy results. Oscar Forel has built a new bridge by which nature is faithfully portrayed but in which his artistic eye has brought nothing less than a revelation. His results have been happy indeed. The synchromies are quite evidently the creations of a subtle artist more discerning than many a fashionable abstract painter, and yet retaining the integrity of his contact with nature.

These superb photographs were first produced in book form in Paris 1961, and ran into a second edition in 1967 in Switzerland. Now they are available to us in an English language version.

I am happy to be allowed to be associated with this distinguished publication, and to salute the perceptive vision of Oscar Forel.

FOREWORD

by

JEAN ROSTAND

Doctor Oscar Forel, son of the famous Auguste Forel, the great observer of the ant world, is himself an ardent naturalist and also a psychiatrist as well as a writer. Until now all I knew of his work was a collection of aphorisms, or moral reflections, in which the wisdom and subtlety of a clinical mind are expressed in lucid terms. He showed he could combine rigour with poetry. But now he brings us these extraordinary pictures of Nature which, by the artistry shown in composition, by their sureness of touch, and with their unusual colouring, would be enough to make all painters jealous, were it not that he has admitted to us that he obtained them by means of photography.

Doctor Forel is the explorer not only of his immediate environs but he has focused his attention on the most neglected parts of the universe. He has found

pleasure in gazing on aspects of Nature which do not usually tempt the human eye. Rejecting too facile effects, he has excluded from his personal vision, the more obvious beauties, the commonly accepted "masterpieces" of living Nature. In this book, the reader must not look for floral splendours, the glow of elytrons or winged transparencies, but little by little he must discover marvels of a different order, more muted and more hidden: strips of bark, patches of moss, tufts of lichen, veils of mould, tears of resin... Nothing "spectacular" but, on close inspection, the most astonishing of spectacles — brilliant sobriety, sumptuous modesty.

Thanks to Doctor Forel's "synchromies", we have been introduced to the most secret works of life. We can see that life as it exists, expands, exercises its strange talents and displays its inimitable artistry, is composed of regularity and disorder, of exactitude and fantasy. We see life inventing, composing, organising, restoring, adapting itself and invading. Each of these manifestations betrays the subtle and sweet power of life's mystery. Is it not the mystery of life alone which can produce all this, which can raise these delicate blisters, delineate these entrancing scars, model these subtle reliefs and deposit this velvety patina?

To introduce us to such obscure riches it was, of course, necessary to magnify them; but the enlargements used by Doctor Forel are not of a kind which transform reality so far that it becomes unrecognisable. Everything which is revealed is still related to us and, however great our astonishment, we are still on familiar ground and we have in no sense left our own world.

What is the reason why the human eye has shown itself to be so sensitive to the spontaneous creations of life? It is the essential relationship of the object and the subject; there would seem to be an unconscious complicity between the seer and the seen. The fact that living beauty is to be found so widely spread around us must not allow us to forget the part played by the cameraman and the artist

in carrying out a work such as this. What endless research, pursuits, hesitations and attempts were necessary to achieve such perfect success! Choosing, isolating, detaching, orientating and emphasizing had to be done. Waiting for the fugitive moment when beauty is at its height, catching the best light, choosing the most favourable setting for the picture... In this book we benefit from the valuable collaboration between the spontaneous genius of Nature and man's aesthetic will, and between natural beauty in all its purity and the learned wariness of taste.

It must also be noted that however skilfully Doctor Forel may have produced these samples of Nature, he has not allowed himself to alter them in any way: there is no artificial colouring, no sacrilegious touching up, and no distortion in the preparation. He has loyally respected the authenticity of his humble models. It is indeed the work of life in its purity which is given to us in these plates. We can contemplate it, meditate on it and be moved by it in all security of mind. It is thanks to Doctor Forel that we are able to see all this, but it exists independently of him. By means of this anthology of living beauty Doctor Forel has "sensitized" us to certain aspects of Nature of which we would know nothing without him. He educates the eye, putting it into a state of alertness: he makes us more attentive, more inquisitive, more searching. I do not believe that anyone who has turned the pages of his book will ever again be able to pass by the bark of a tree blindly... Henceforward we know that every corner of Nature's territory holds an inexhaustible reserve of beautiful surprise which is ever ready to provide a spectacle worthy of our attention.

In this unveiling of unsuspected "infra-Nature", what a gift has been presented to us! We have been given fresh pretexts to look around us, added incentives to value our world, and countless threads of beauty to attach us to our planet. And, in addition, what a lesson in wisdom!

It is always salutary to remind man of the ubiquity of the essential.

AVANT PROPOS

"Synchromy"... What is the meaning of this neologism? As "symphony" expresses the harmony of sounds, so synchromy can claim to evoke that of the colours which we find in the barks of trees. There exists a world to be seen somewhere between the field of vision of the microscope and that of the naked eye. When sufficiently magnified its own structures are revealed, and they are of an unsuspected and sometimes unusual richness; but this world and its colours is not so strange as to make us doubt that it is real.

Life is more than bare eternal renewal. There are shapes and colours which evolve and are affected according to time and place, whether they are to be found in the depths of the forest, on the verge of a wood or the edge of a marsh, on fertile soil or on scree. They vary too according to geological environment, altitude, degree of insolation, latitude, season and weather. Indeed, some of these conditions change so fast that certain objects registered on a given day may no longer have the same interest for the beholder a short time after. Here then is evidence of another mystery, namely, that every single living object, whatever it may be, is an unique being in the world. To the naked eye some objects are identical, but under the magnifying glass there are only resemblances: beyond the scope of our native myopia there is a world which invites us, waiting to be discovered.

In rainy weather the forest reveals colours: hitherto they have been kept hidden by the mat, and usually dust-covered, barks of the trees. Some of these barks

then display astonishing patterns, exactly like hieroglyphs, and varying from one species to another; once they have been washed these colours sing out for us just as the flowers give out their scent. Subtle blends and shades, all related to exposure and lighting, all are present and always in harmony with the living background. Thus it is easy to distinguish between the synchromies deriving from Northern regions, where the melodies are sung in a minor key; there, everything is pale and often dull and cold, whereas the synchromies of Southern and especially tropical regions are striking in their often provocative exuberance. The forest calls to mind an orchestra in which the oldest tree is the soloist, playing the themes and inviting the audience to integrate itself in the symphony of all the players.

In more exposed situations, particularly in mountains, a solitary tree may carry the scars of numerous wounds, the stigmata of its struggle against the elements, lightning, frost and drought. Even the movements of the trunk, of the branches bending under the weight of snow and avalanches; even the wrinkles and the chiselled crevices of the bark are witness to an epic struggle for life which is sometimes a hundred years old. They also proclaim the victory of the vegetable over the mineral world, if man does not interfere and endanger it.

Bark, in the same way as stone, becomes covered with a patina, often luxuriant and of infinite shades and colours, and with mosses and lichens, fungi and moulds, either visible or invisible to the naked eye. And what finery in the vegetable world comes with that patina! Without it, so many regions would merely be lunar landscapes; with it soil, stones and forests spring to life again. A little pollen dust, a wreath of mist, a wave of warmth, and everything comes alive: a balanced universe in which the harmony of colours combines with that of form and structure.

The controversy raised by the affinity between art, photography and synchromy will not be over for a long time. But when it is seen that many of these colour

plates recall works of art one wonders whether certain painters were not subconsciously inspired by examples drawn from this world which might be termed sub-visible. Certain of the synchromies produced in this book are even related to abstract painting. But this can only be an appearance. For one thing, they were seen through a lens, whereas a work of art will always depend on the projection of a visual effect created by the sensibility of the painter: on the other hand the richness of design, and the subtlety of colours which are always complementary, are such that one can but bow to the endless resources of Nature's inexhaustible imagination.

The appreciation of synchromies, which is shared equally by amateurs, by many artists and in particular by young people, seems to derive from the fact that these plates illustrate the common source of all the arts. In Nature, and especially in the forest, man rediscovers the land of his origin, the cradle of life. In it he sees the immutable fan shape that Nature gives to her fundamental norms, the infinite variations on themes and the rhythm and dynamism of biological structures in a state of perpetual growth. We see the contrast in the rigid immobility, the monotony and the wearisome repetition of outlines of our urban constructions: ten thousand identical doors, a hundred thousand matching windows. Such is the penalty we pay for a technique subservient to an economy, a process which appears to be irreversible.

I am often questioned on the origin of synchromies. Perhaps I may be allowed to recall an old memory: when I showed the first proofs to my old professor of natural history, he was moved to enthusiasm and asked me: "What ever led you to the discovery of those marvels?" My answer recalled to the octogenarian the activities of his early years, at the beginning of the century: "Instead of teaching us in the classroom, you used to take us to the edges of the lake and the marshes, and into the forests: between one lesson and the next you taught us how to observe Nature and make our own discoveries. So you are the

godfather of the synchromies!" My old master said nothing; but his tears expressed better than any words what this tardy homage meant to him.

There followed four years of active service during the First World War when I lived for many months with an Alpine regiment on the Italo- and Franco-Swiss borders. Countless days were spent on patrol in the mountains among the Arolla pines, with larch, alder, birch and fir to protect the pasturelands and valleys against avalanches, floods, erosion and everything which endangers vegetation. The most isolated trees, which are at the mercy of the elements, tortured and mutilated, are those which gave me the key to the secret language of their barks; it is a secret which is revealed only to the man who remains in their company for a long time, and alone.

After the Second World War, when I had reached retirement age, the surrounding walls of an old family property slowly revealed to me the splendour of their vegetable patina.

For some years my search for synchromies was confined to the Jura and the Alps. But from 1955 onwards each year brought the exploration of some new country: Finland, France, Morocco, England, Canada, the U.S.A., Jamaica, Ceylon and the Canary Islands.

In Paris on the publication of the first volume (1961), there was an exhibition in the Pavillon Marsan of the Louvre. This was followed by others: at Lausanne in 1962 and 1970 on the occasion of the "S.O.S. Nature" exhibitions and displays which were organised in all countries of Europe under the auspices of the United Nations; at Darmstadt in 1966 under the auspices of the Goethegesellschaft; and at Montreux in 1968. At the present time travelling exhibitions are being shown in the U.S.S.R. and in the United States.

What then is it which gives so many trees this dignified appearance? The answer seems to lie in the fact that whereas animats fly at the least sign of danger, trees confront their fate where they stand, with no other sound of protest

than the noise dragged from their branches by the wind. They will die as they have lived, impassive, with their foliage covering the young shoots which await the revival of life.

It is my hope that these reflections may help to widen the discussion, without restricting the problems raised by synchromies to the field of art alone. Thinkers and art critics maintain that there is interaction between biological and fundamental aesthetic ideas. It would certainly seem that these similarities support our argument, namely, that everything which we declare to be beautiful, harmonious and well-proportioned obeys the same laws. An unchanging order determines our criteria in aesthetic matters. On the other hand, that which infringes the biological order instinctively shocks and displeases us. Industry imposes geometrical structures whereas Nature, that tireless builder, ignores rigorous symmetry, right angles, the T-square and the compass. Identical trees or identical leaves do not exist. Ceaseless disintegration and renewal, which are in effect Nature's universal workshop, as well as the alchemy of biology create this perpetual metamorphosis, this continuous flow from which monotony and boredom are for ever banished: Geometry is to Nature what the metronome is to music.

In the mountain ranges of the Alps, the Pyrenees and the Atlas some woodlands have survived the devastation of so much land clearance: here are virgin forests still peopled by witnesses whose bark bears the scars of a life already forgotten by the living, and by skeletons now mutilated by storms and avalanches. One is struck by the grandeur of the fresco. Here, nobody has improved on Nature; the age-old trunks, felled by the weight of centuries and marked by the ordeals of time, pale shapes bleached by the sun, with jagged stumps and broken branches, these defeated giants lie strewn on the floor of the surviving forests...
It is to these forests that this book is dedicated

Oscar Forel

LIST OF ILLUSTRATIONS

Euphorbia disclusa

A variety of spurge, imported from Ethiopia. Madeira, Portugal.

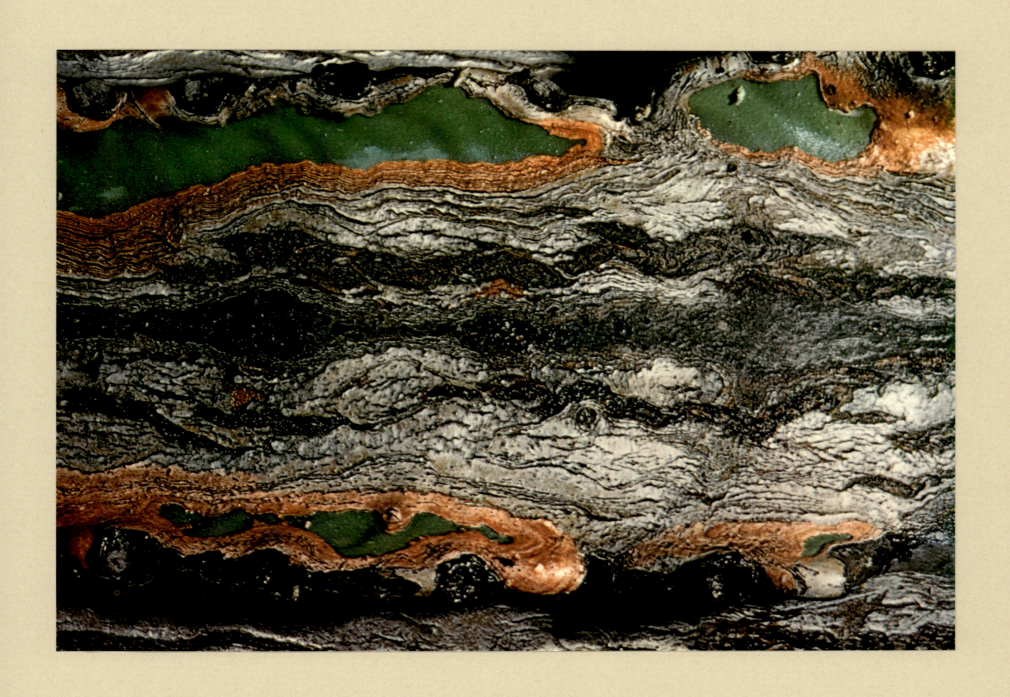

Musa paradisiaca

Banana Tree - Peeled bark. Morocco.

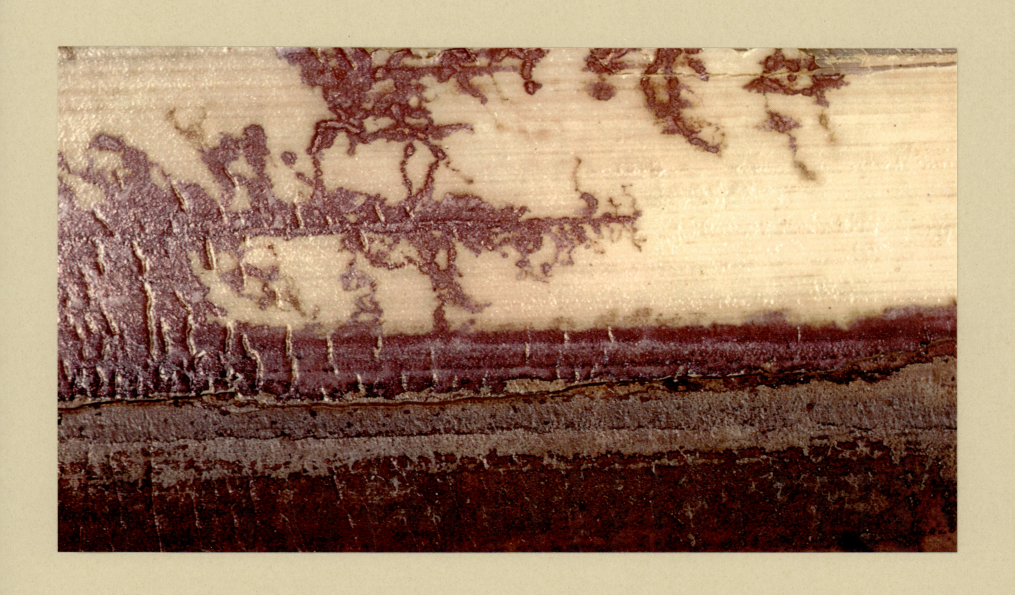

Arecastrum romansoffianum

A species of palm tree. Ceylon.

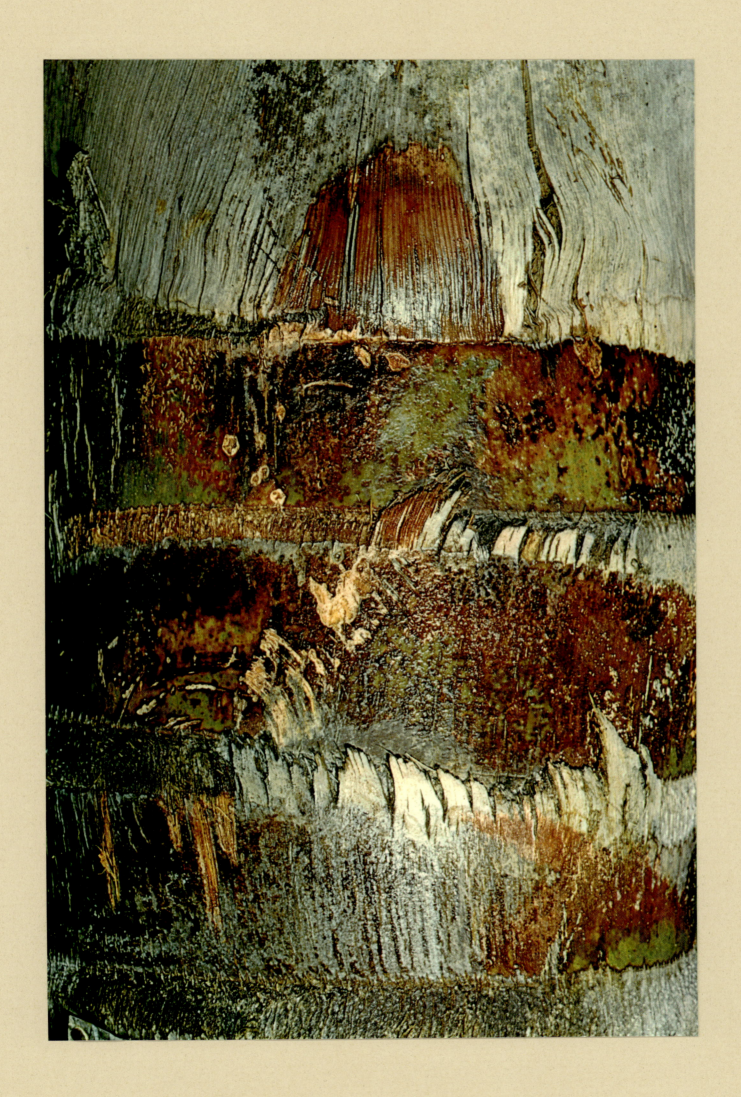

23

Musa paradisiaca

Banana Tree - Peeling of the lower part reveals the capillary vessels. Saint Ann's Bay, Jamaica.

Pages 26-27

Prunus japonica

Japanese cherry. Kew Gardens, London.

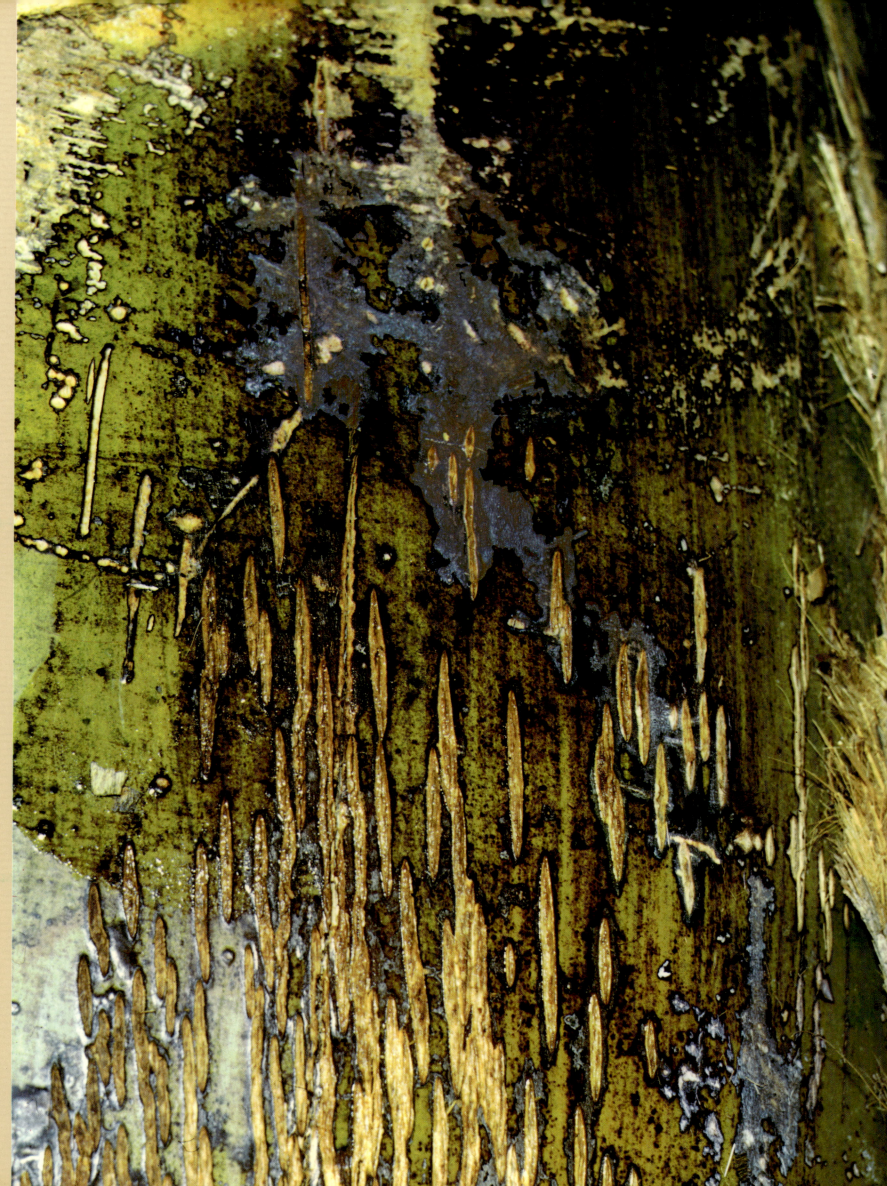

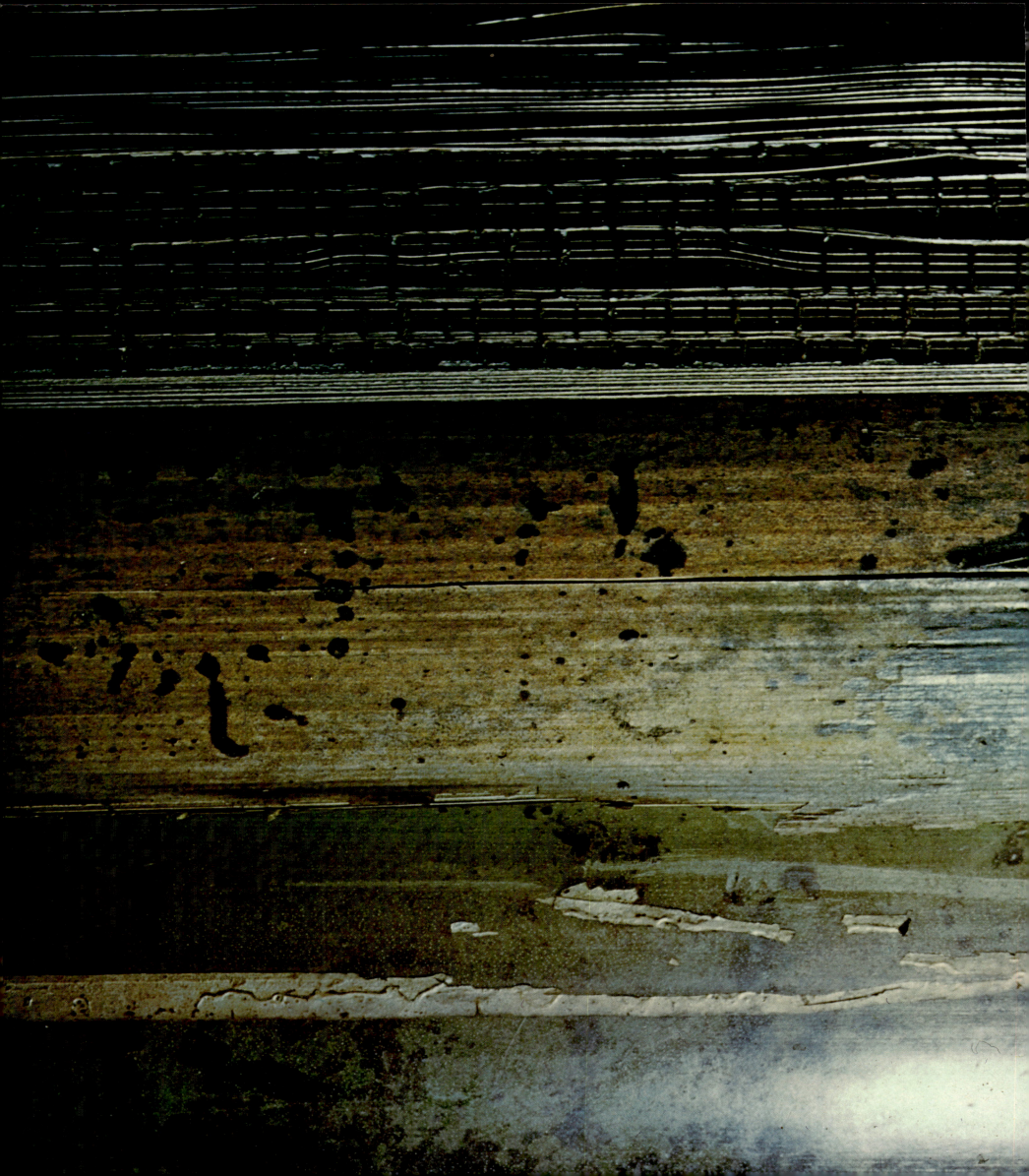

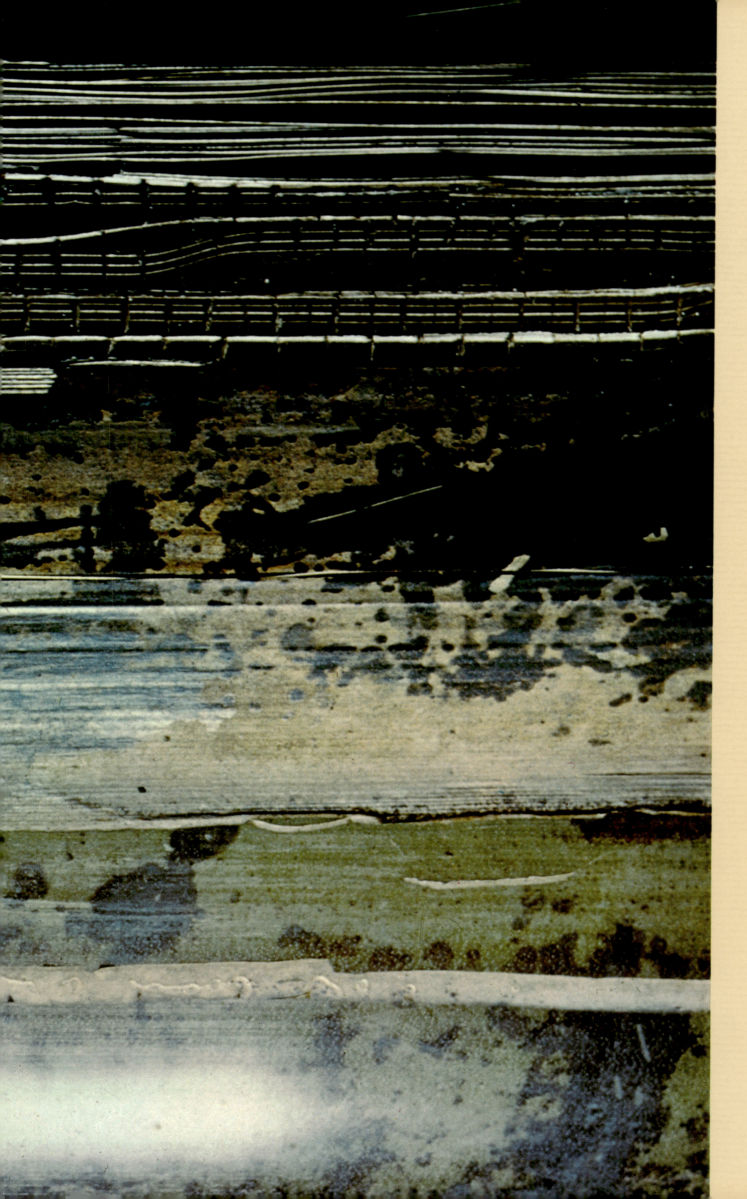

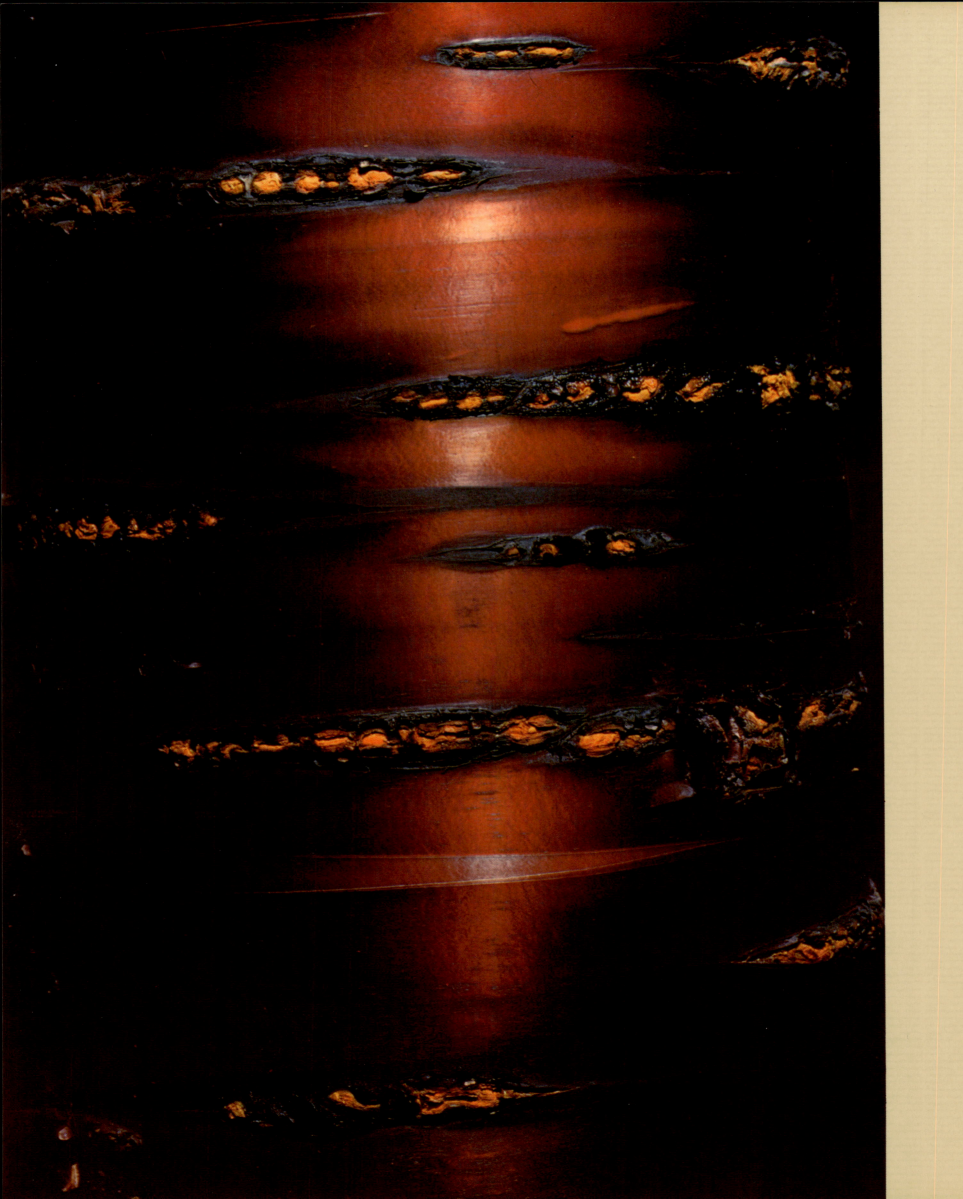

Cocos nucifera

Coco-nut palm - husk of fruit. Kingston, Jamaica.

Eucalyptus

Gum tree. North Africa.

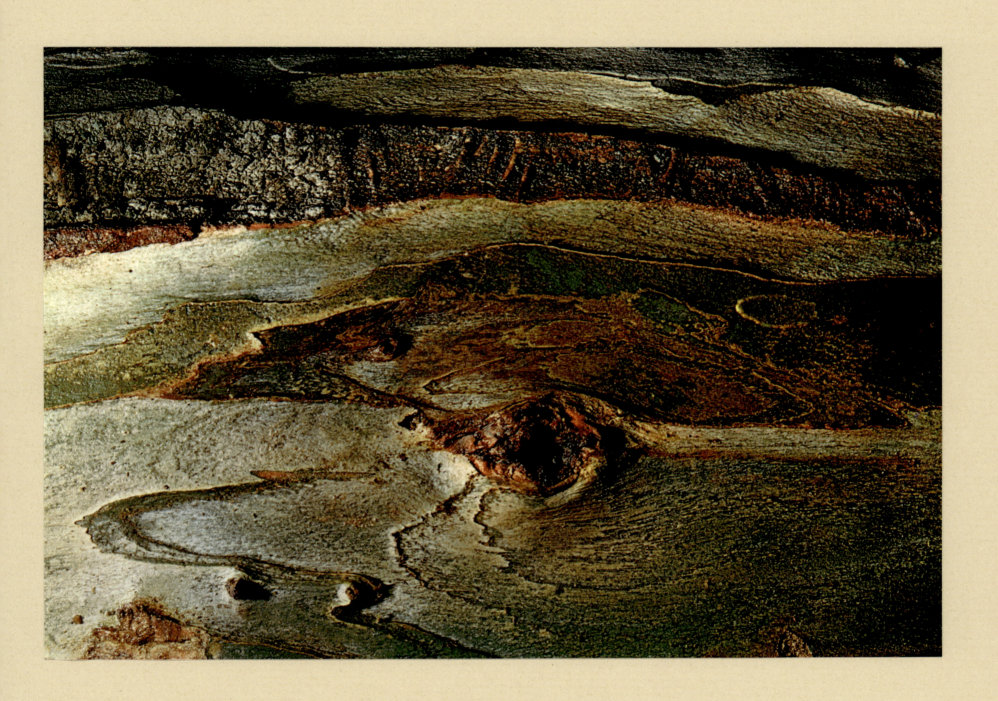

Liliaceae

Liliaceous species. Cap Ferrat, France.

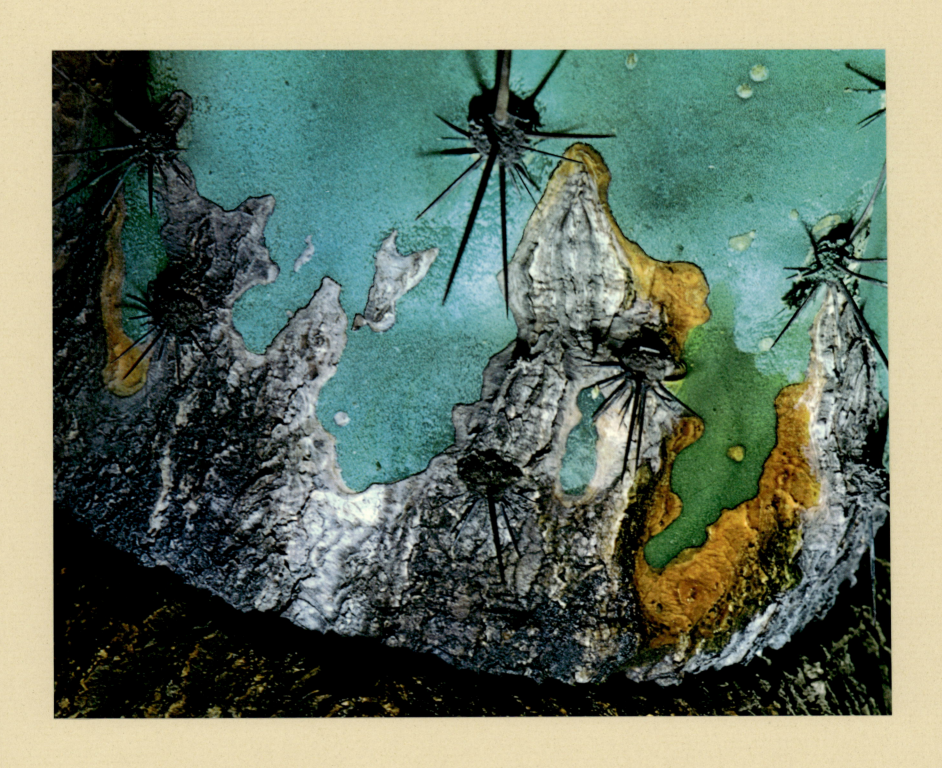

Ferocactus robustus

Ferocactus. Cap Ferrat, France.

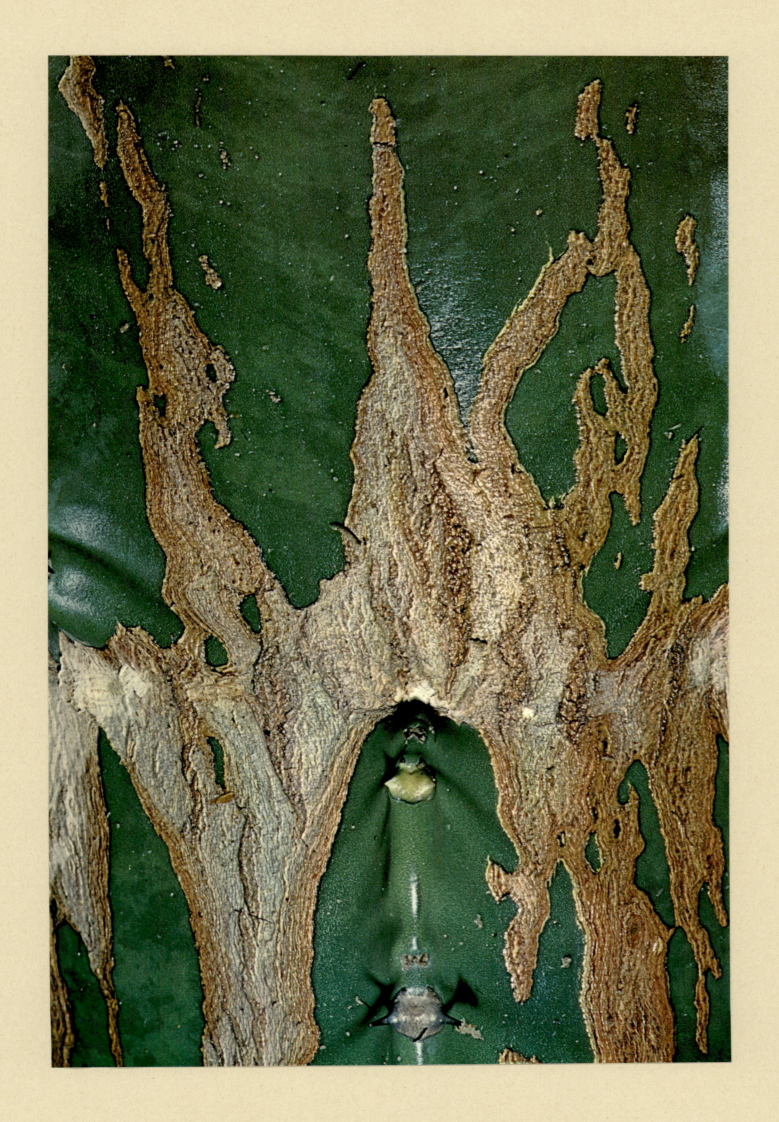

Livistona chinensis

Chinese palm. Cap Ferrat, France.

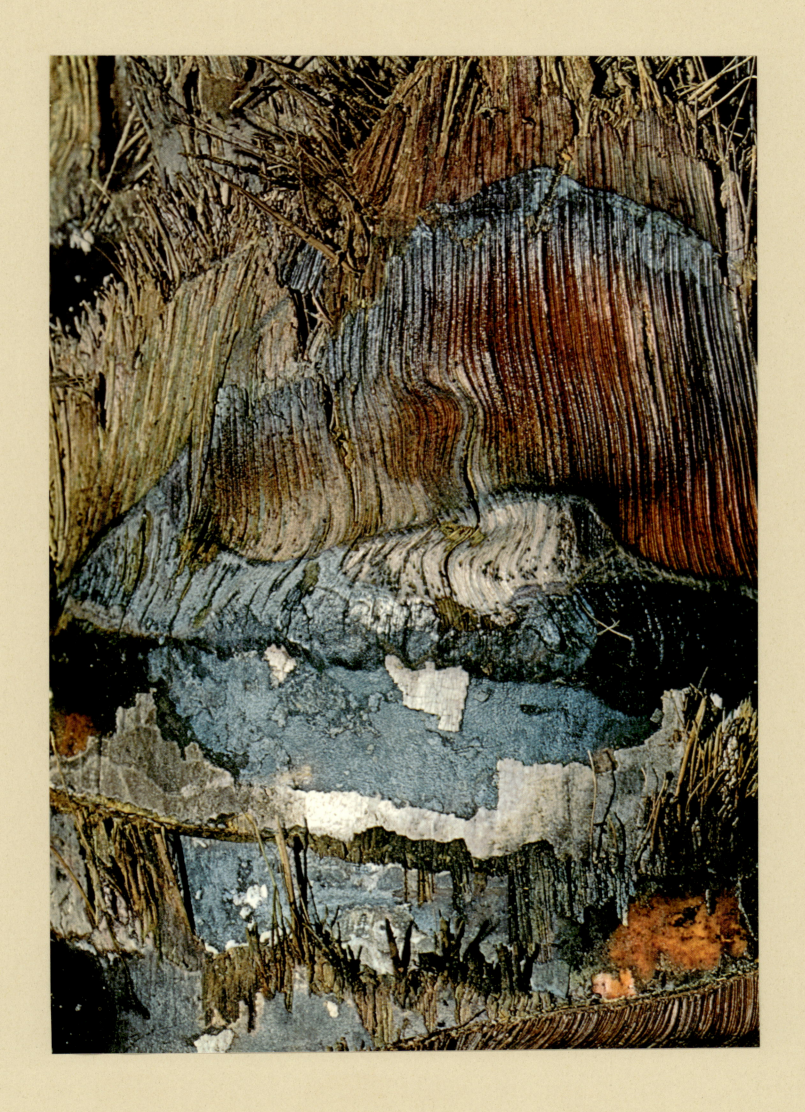

Betula alba

Common birch - Moulds on the internal surface of bark. Finland.

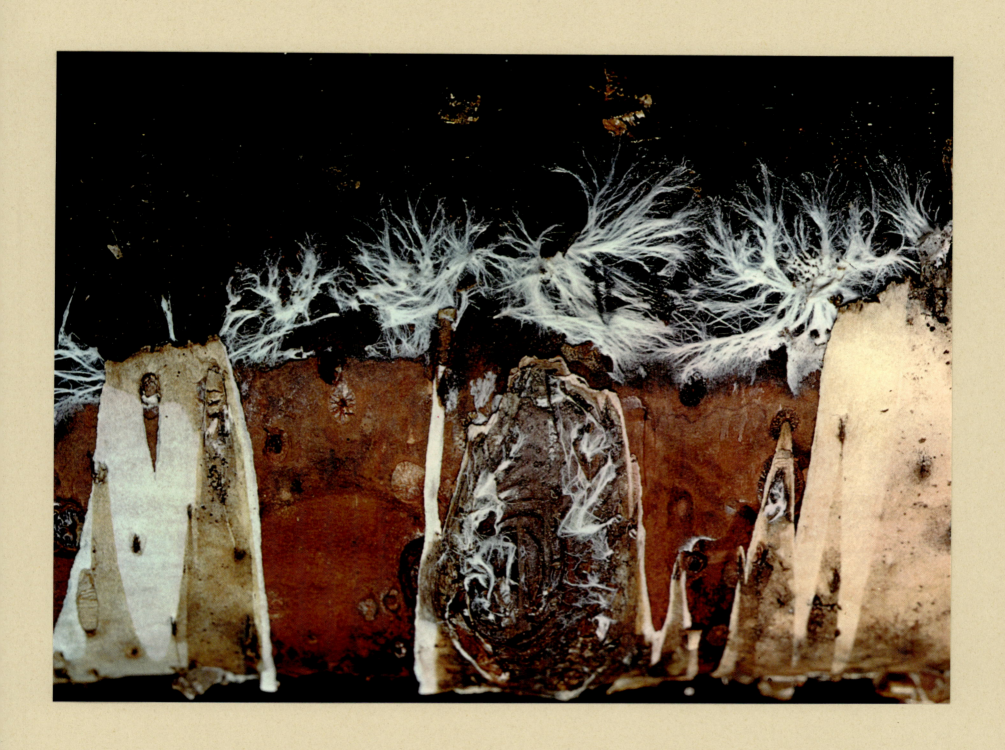

Picea excelsa

Common spruce - Worm-eaten trunk covered with cryptogams. Derborence, Switzerland.
Pages 42 - 43

Betula lutea

Yellow birch. Rocky Mountains, Canada.

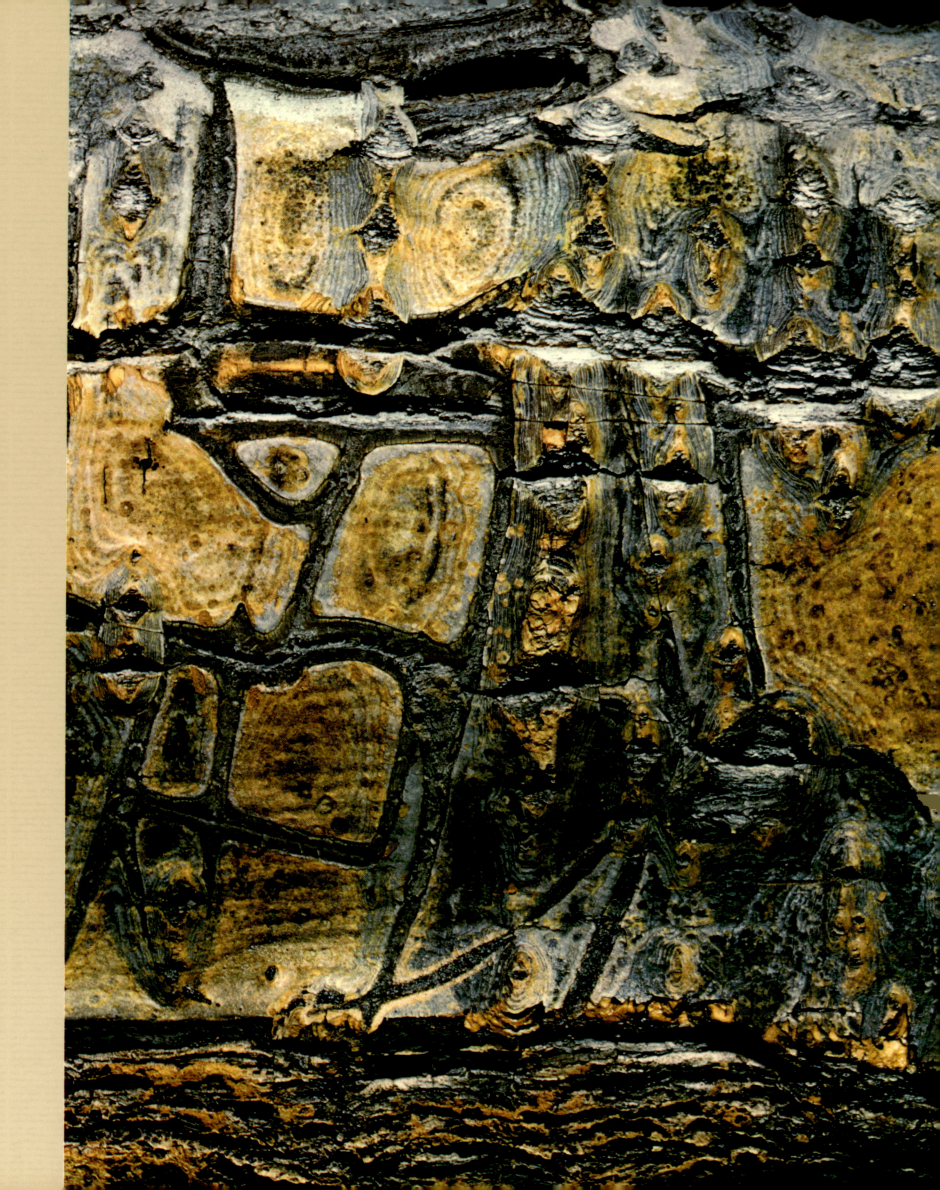

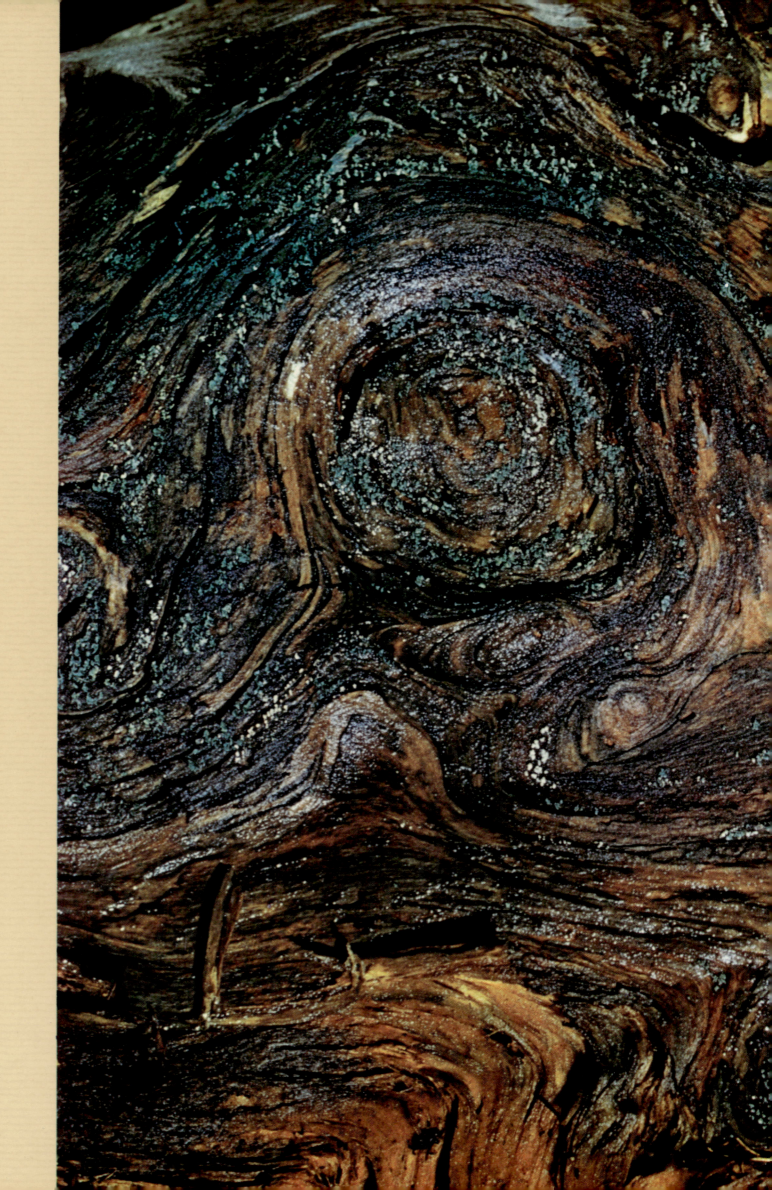

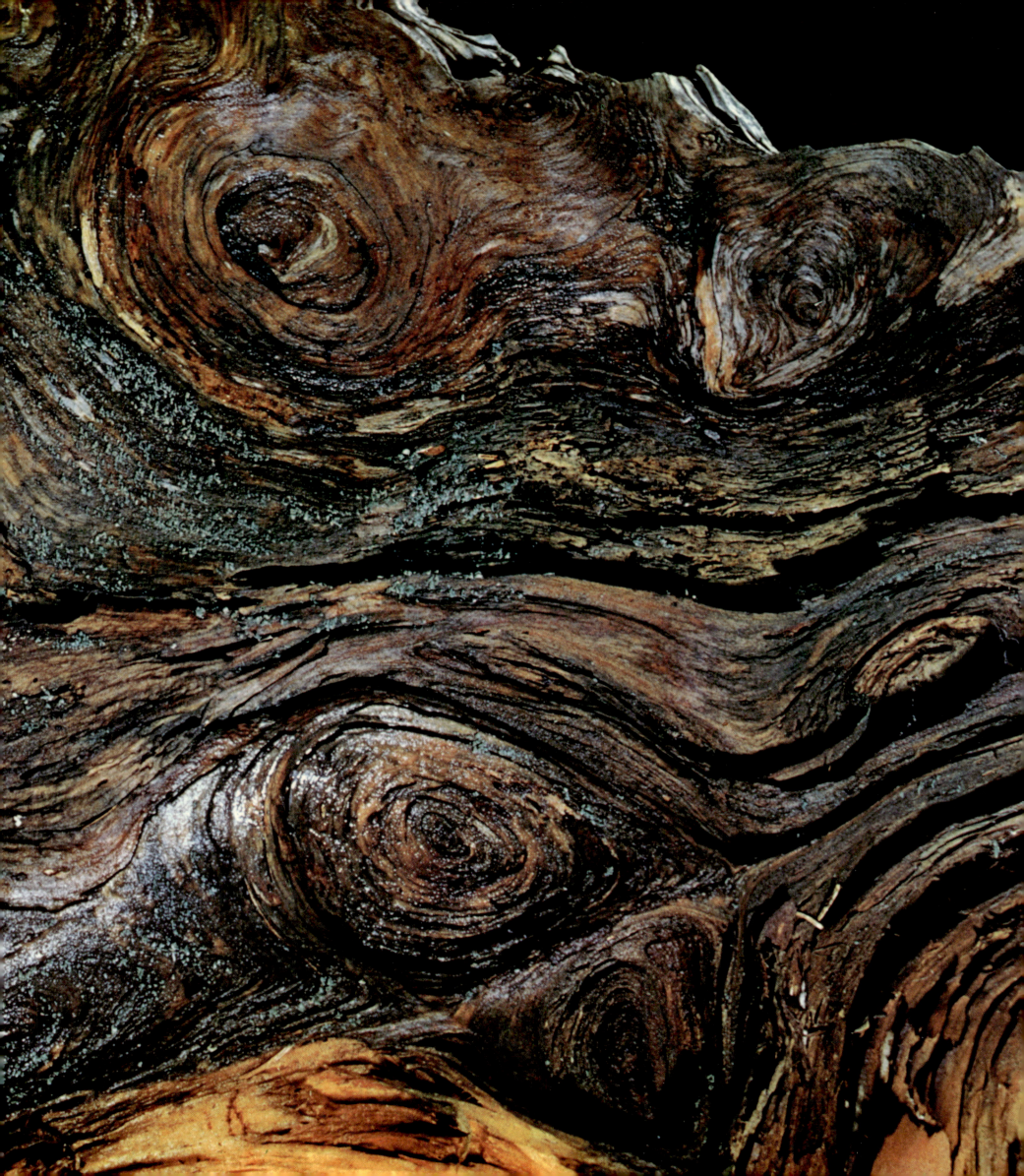

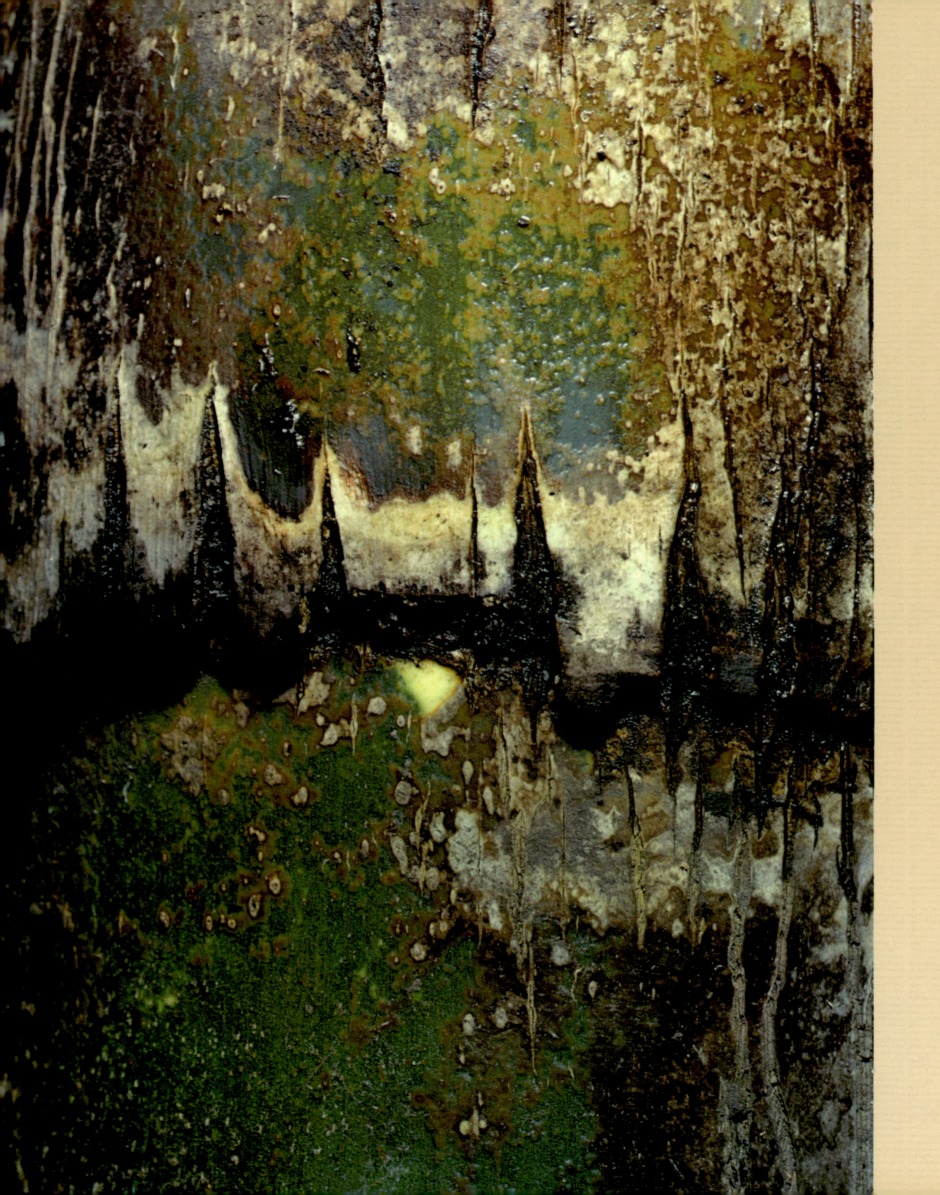

Betula lutea

Yellow birch - Dead specimen covered with lichens. Central Jamaica.

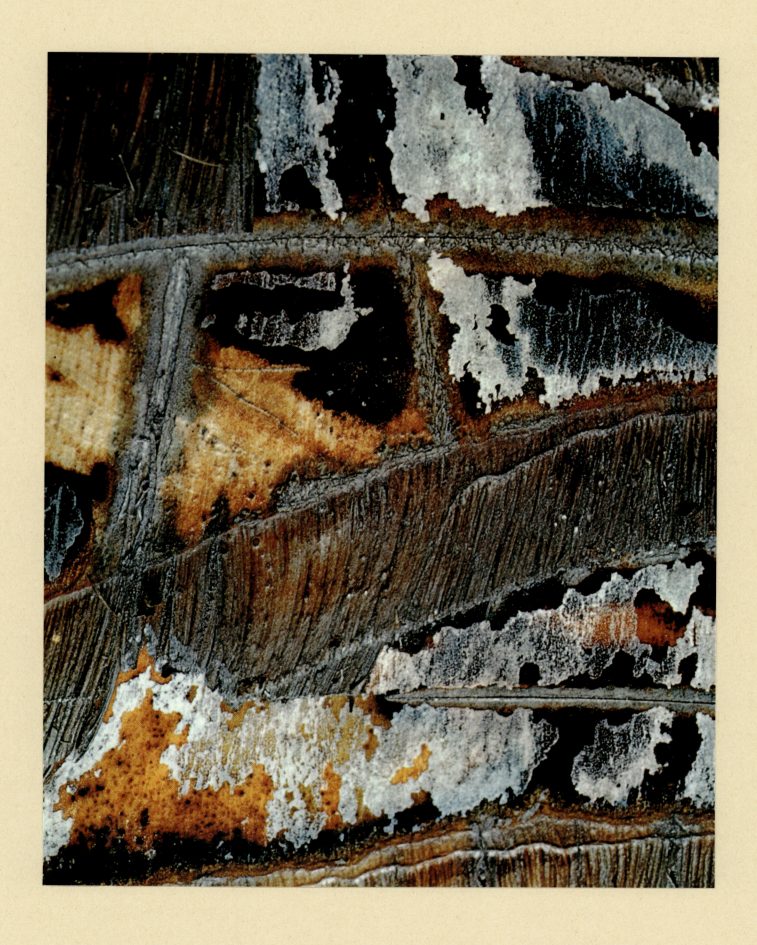

Picea excelsa

Common spruce - Disbarked trunk of a specimen struck by lightning and in process of decomposition. Derborence, Switzerland.

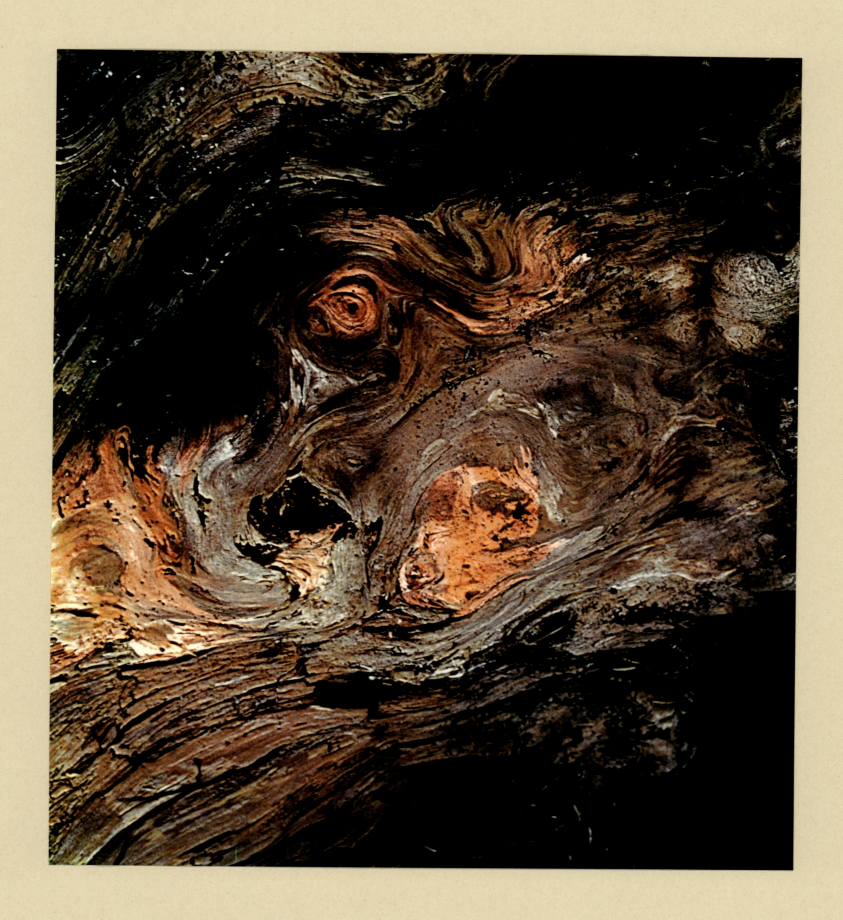

Pterocarya fraxinifolia

Wing nut. Caucasus.

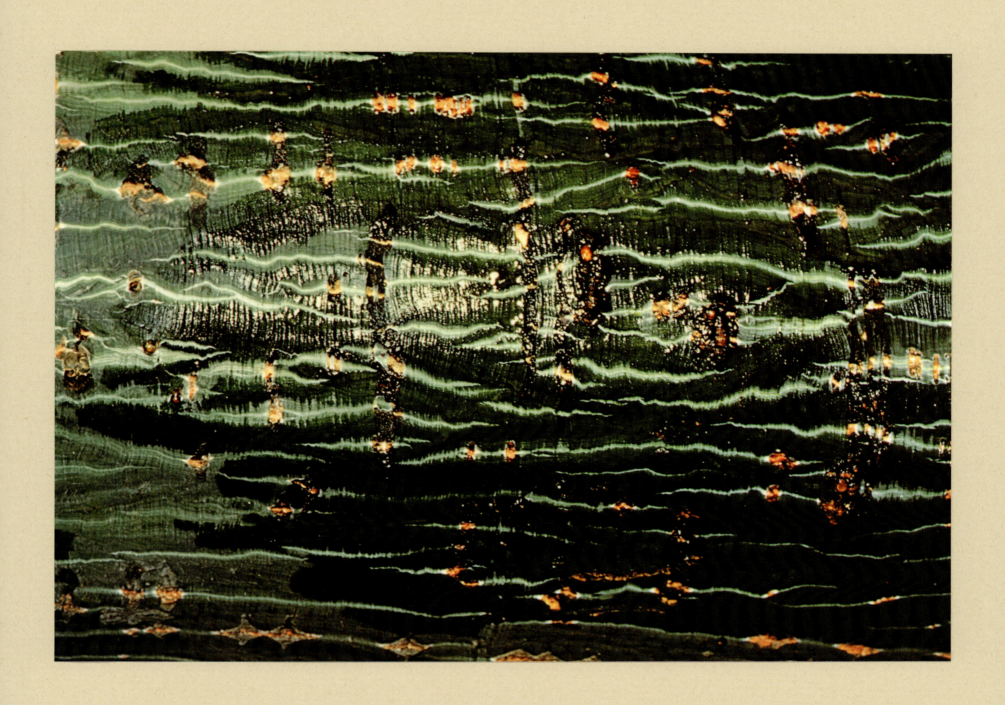

Palm tree - Intersection of large basal leaves. Ceylon.

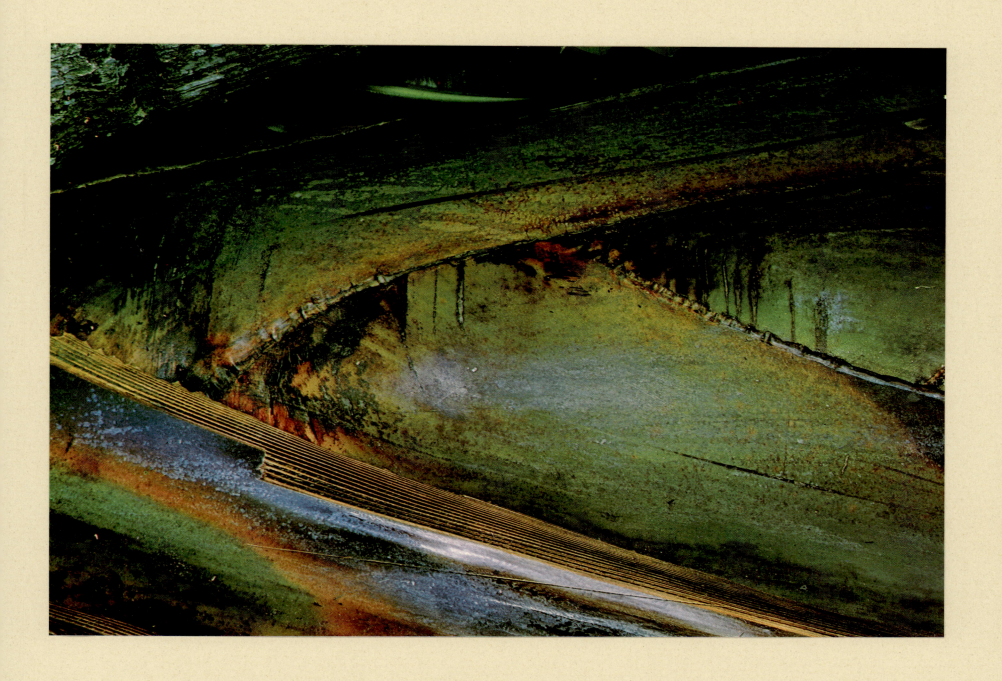

Artocarpus incisa

Bread-fruit tree. Jamaica.

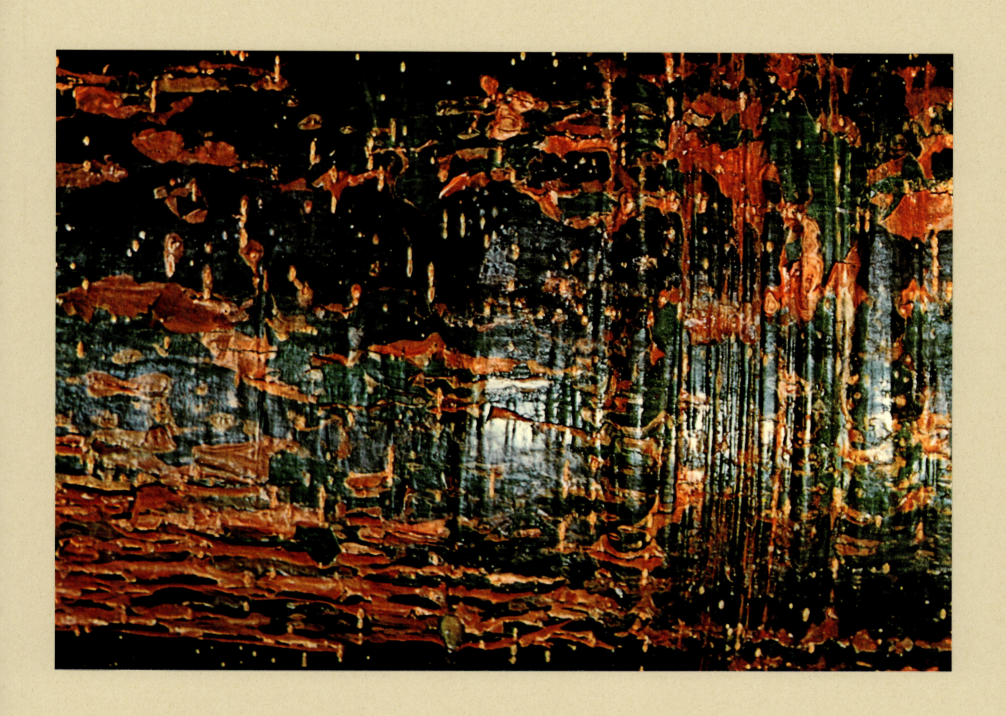

Eucalyptus globulus

Blue gum tree - Peeled bark. Oued R'Mat, on the road to Ouarzazate, Great Atlas, Morocco.

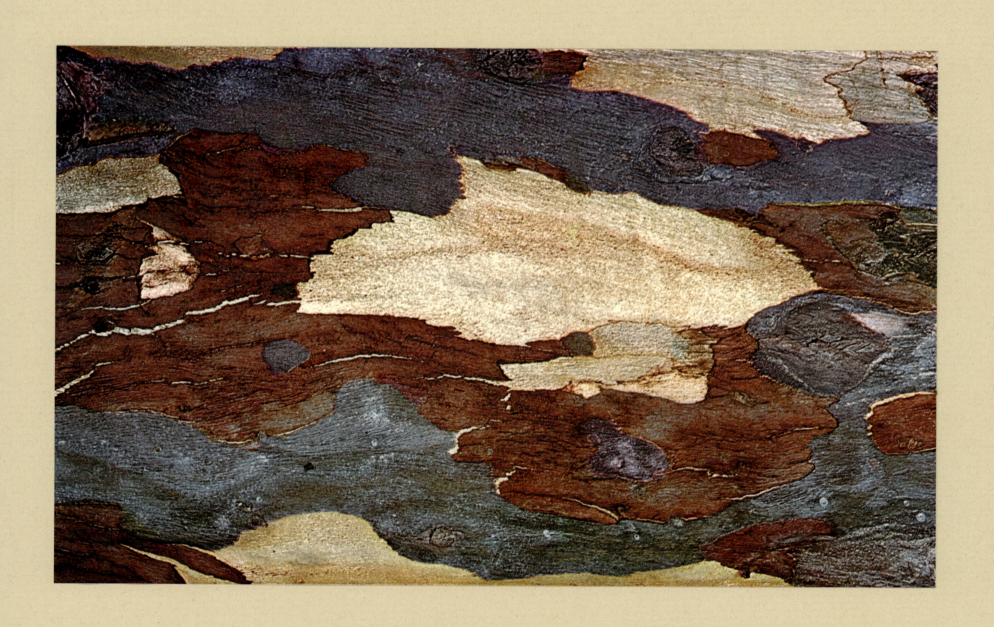

Pinus silvestris

Calcined sap-wood of Scotch pine. Lake region of Finland.

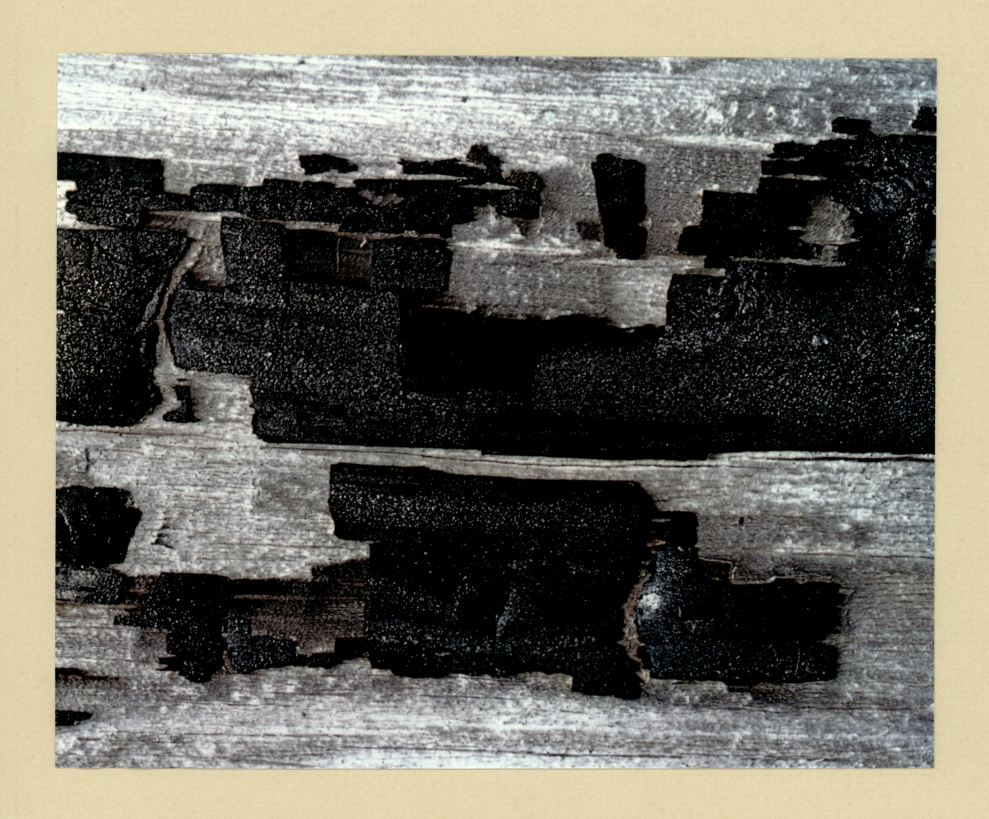

Musa paradisiaca

Banana tree. Kandy region, Ceylon.

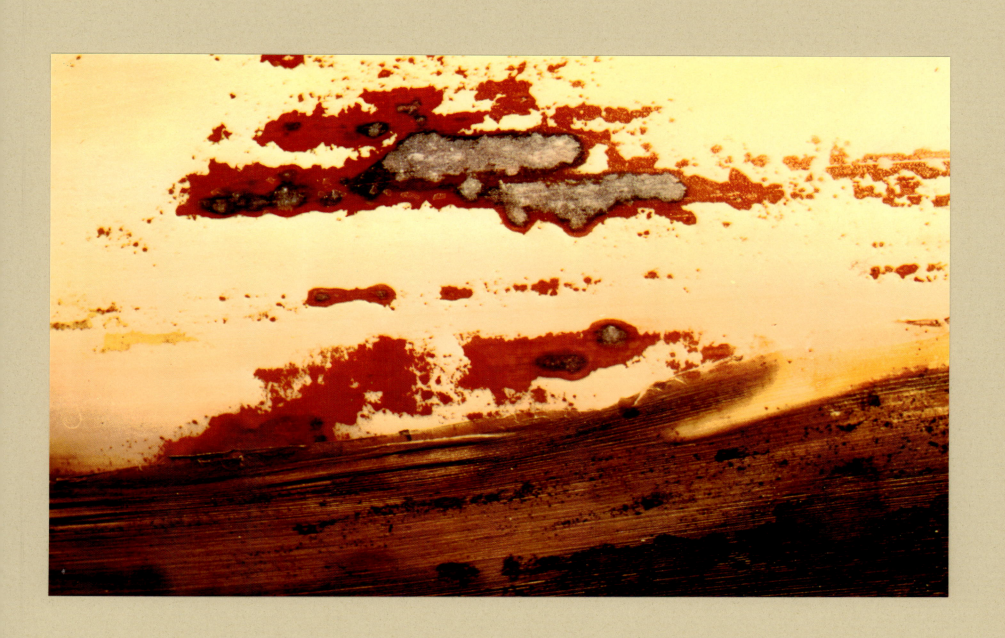

Pyrus communis

Common pear. Shores of Lac Léman, Switzerland.

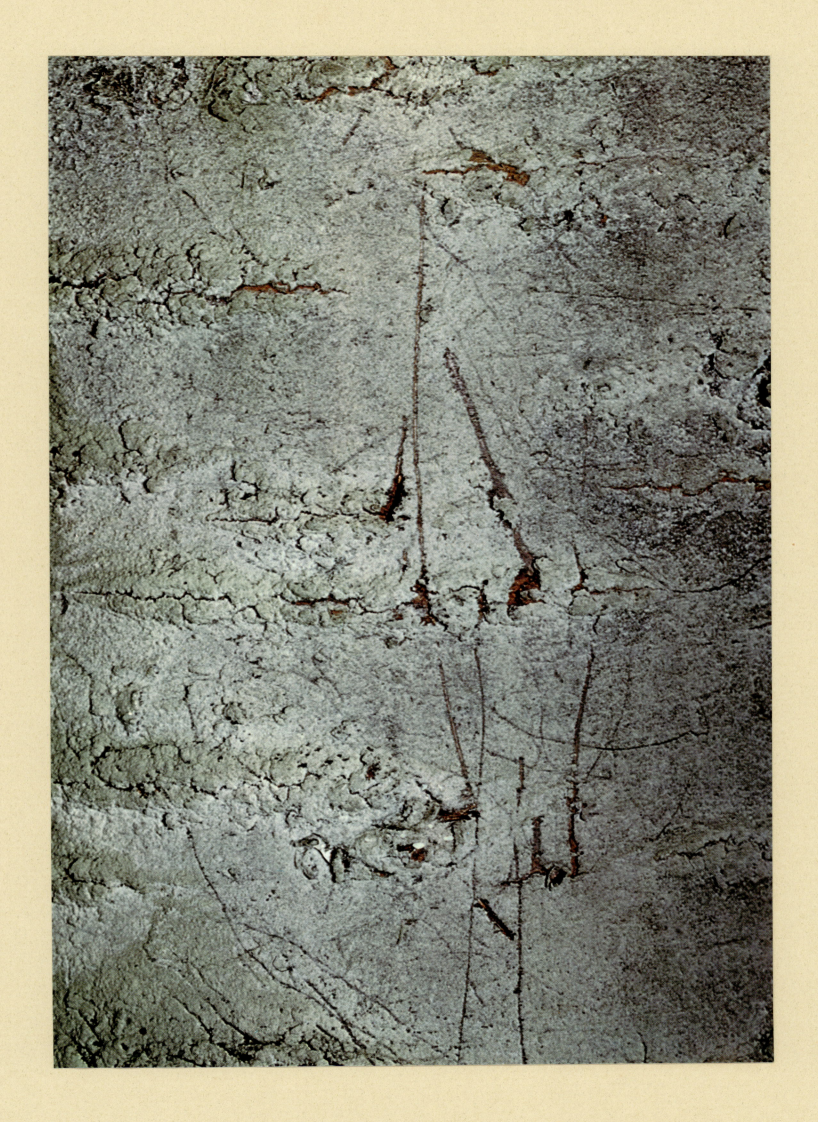

Philodendron

Philodendron - Surface of dead trunk. Tenerife Island, Spain.

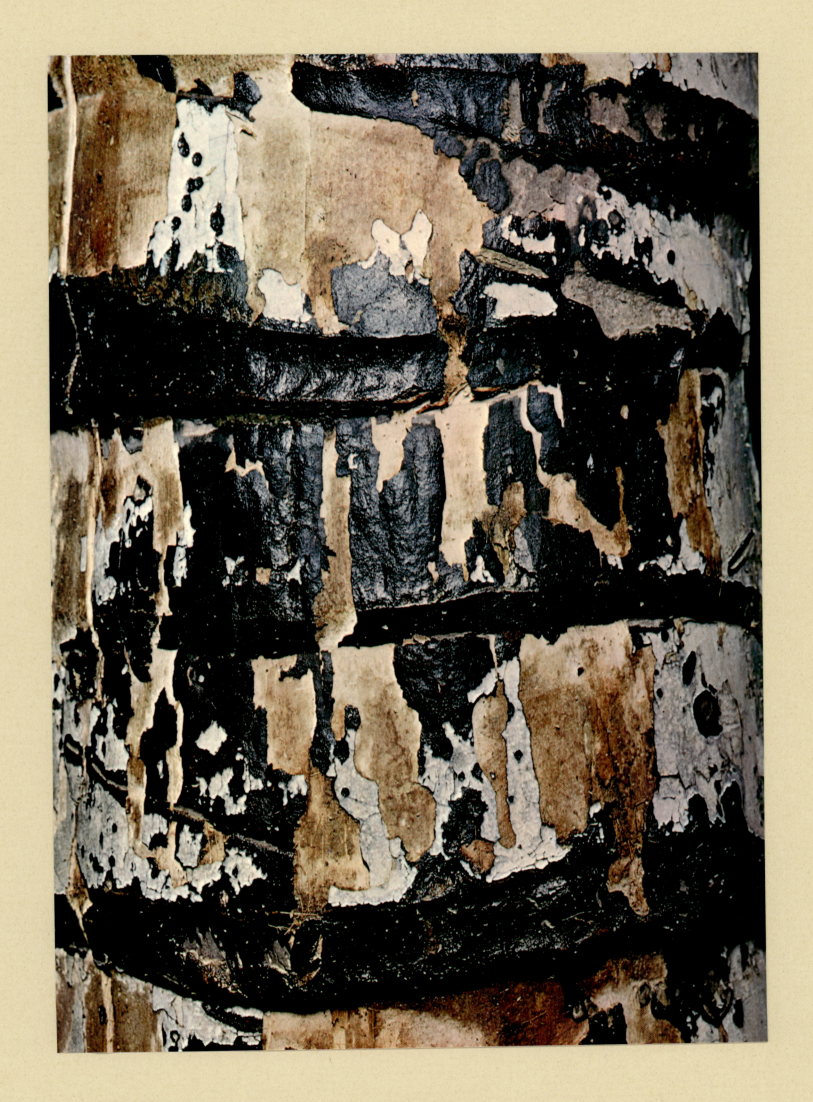

Acer campestre

Common or field maple. Lac Vert, Jura mountains, Switzerland.

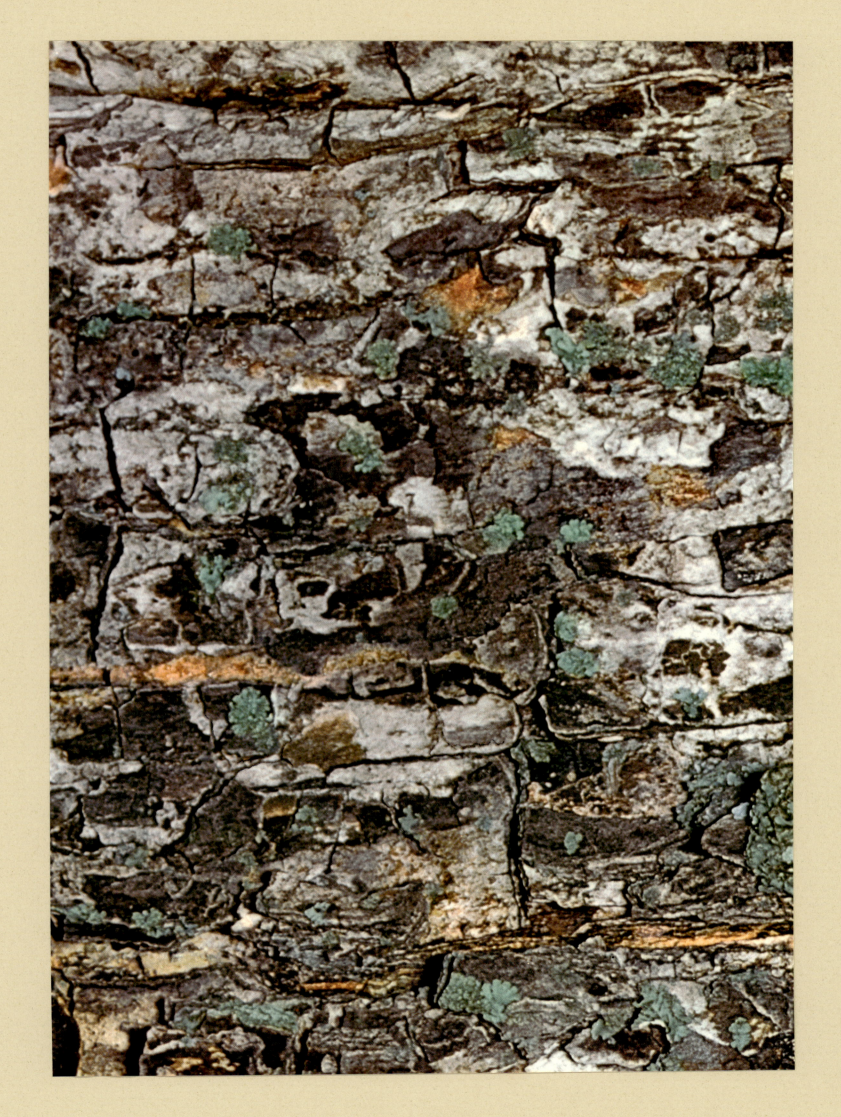

Sorbus aucuparia

Mountain ash or rowan tree - An old, deep wound. Les Diablerets, Switzerland.

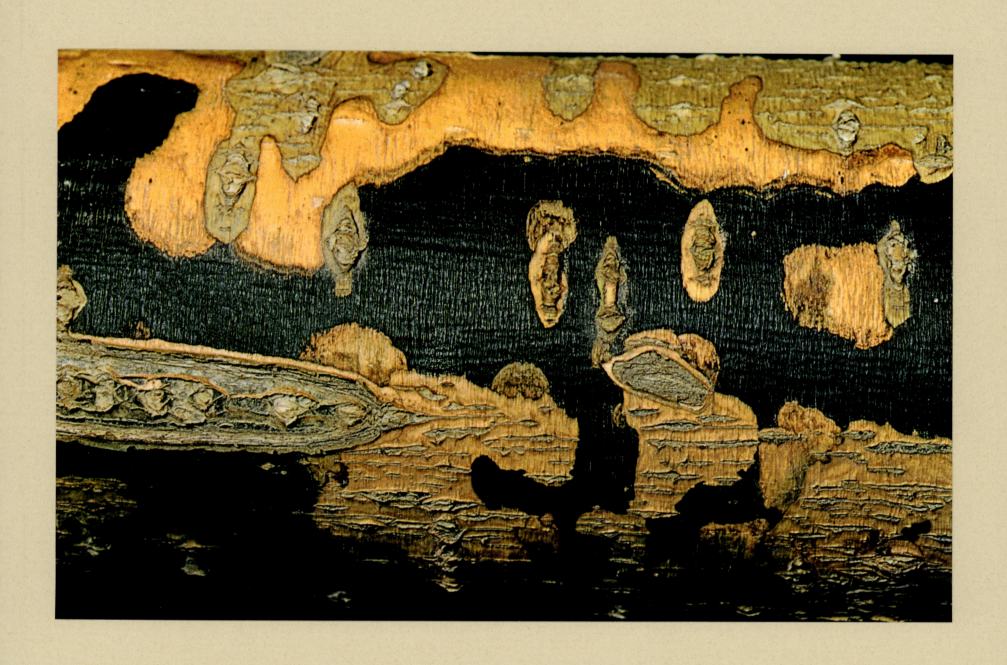

Palm tree, leaf scars. Kingston, Jamaica.

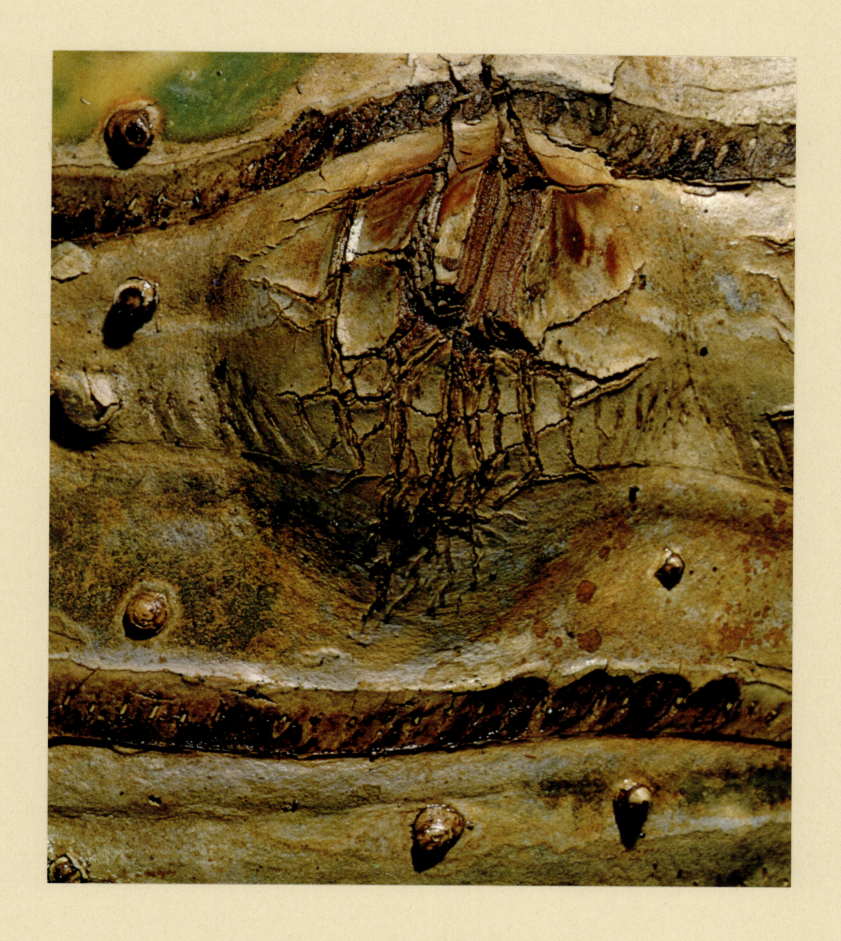

Pandanus utilis

Screw-pine. Native of Madagascar.

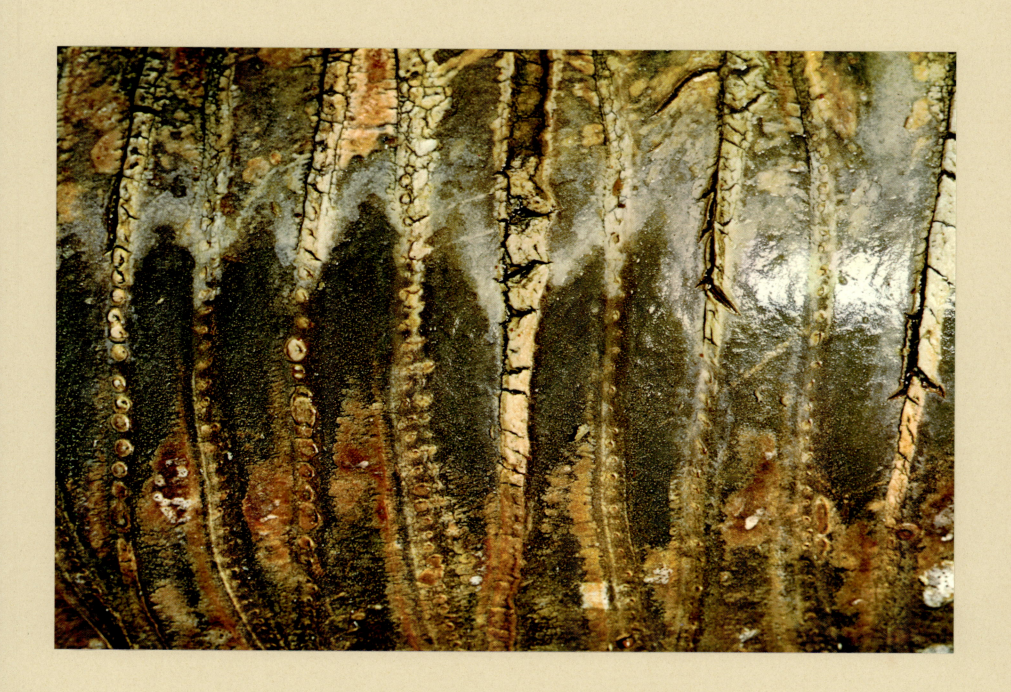

Betula papyrifera, var. cordifolia

Paper or canoe birch. North America.

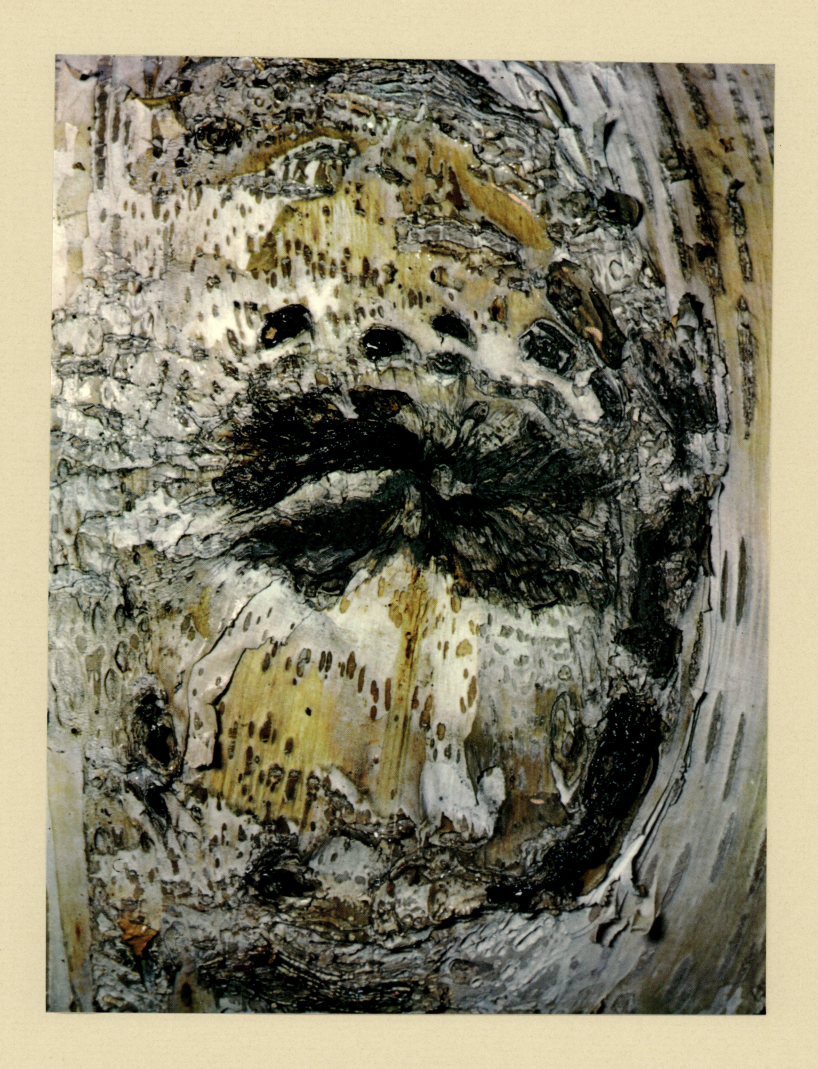

Pinus silvestris

Scotch fir - Sap-wood after several years in damp and dark. Finland.

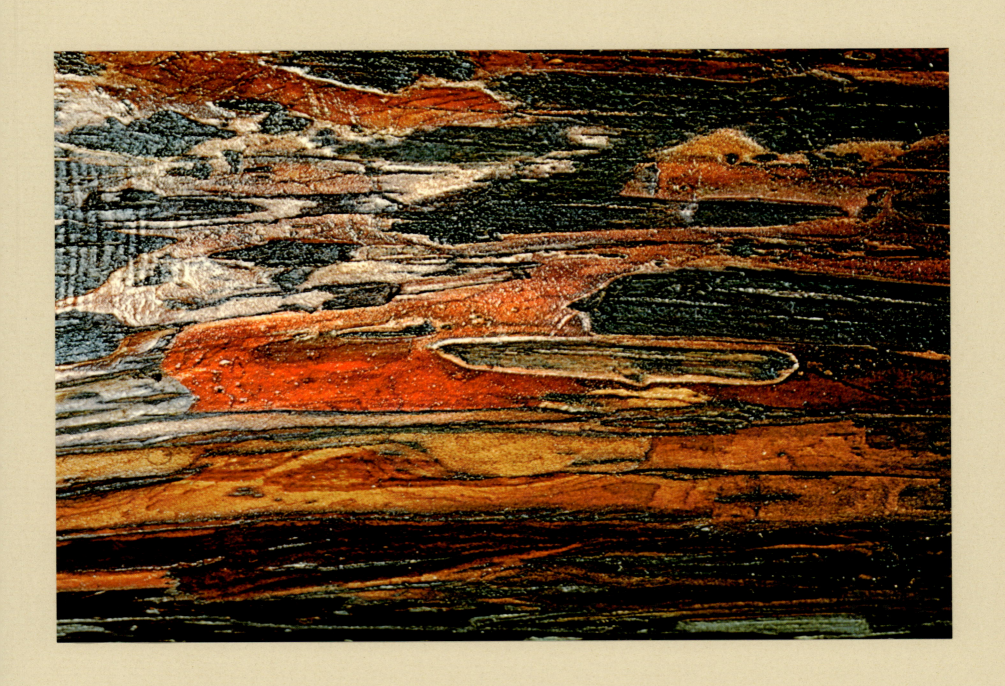

Betula alba

Common birch - Internal surface of partly peeled bark. Finland.

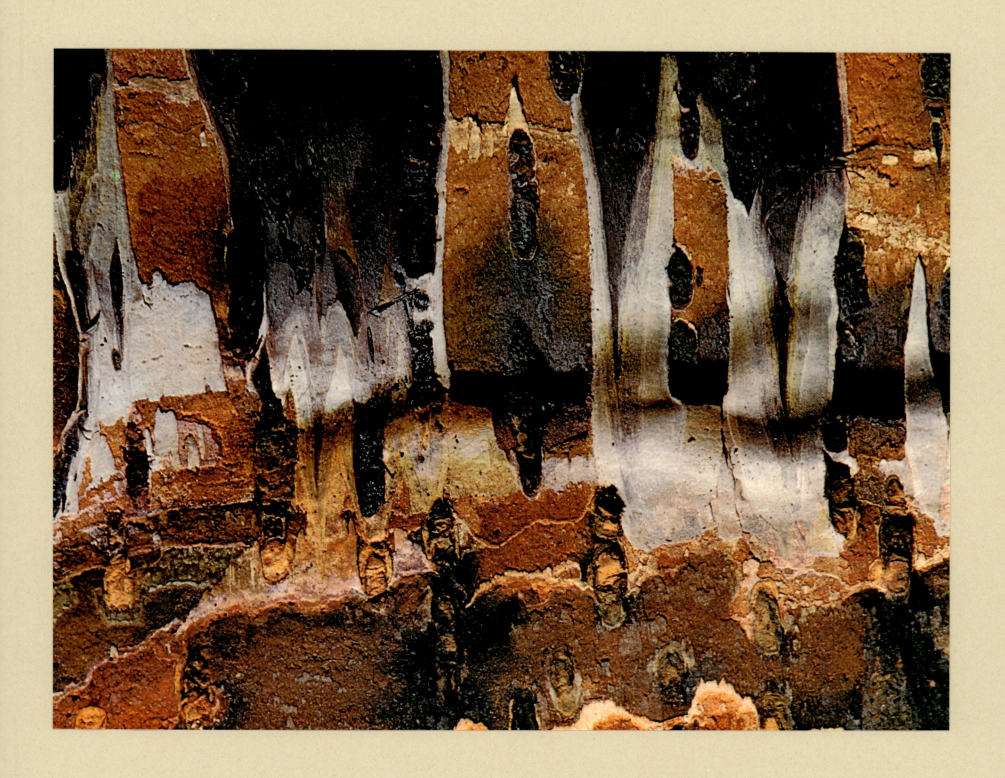

Bark of unidentified tree. Borromean Islands, Italy.

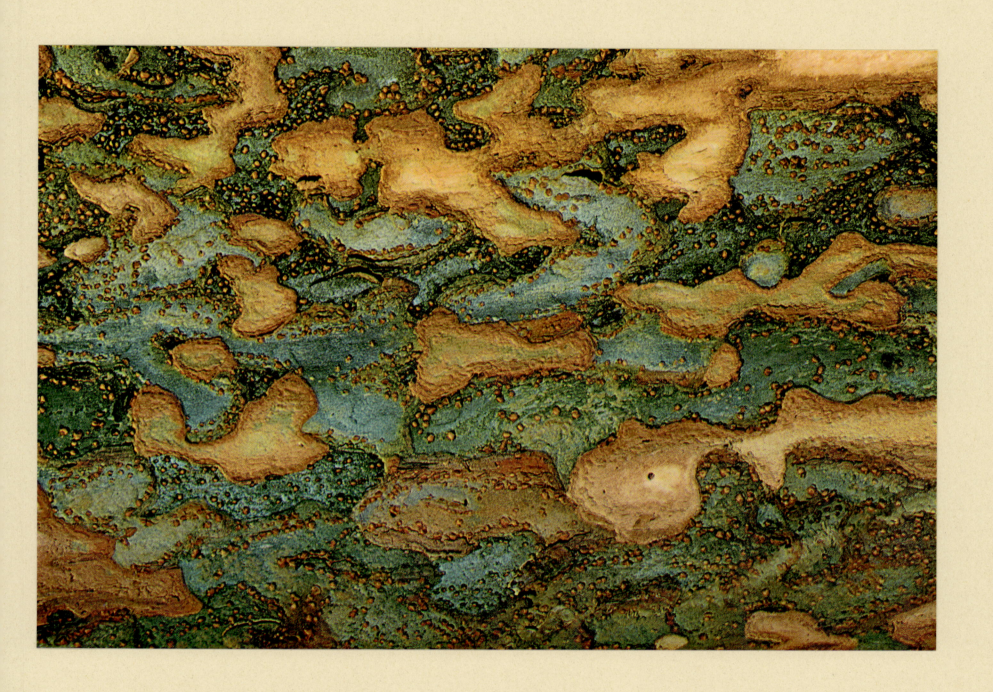

Eucalyptus naudiniana

Gum tree. Ceylon.

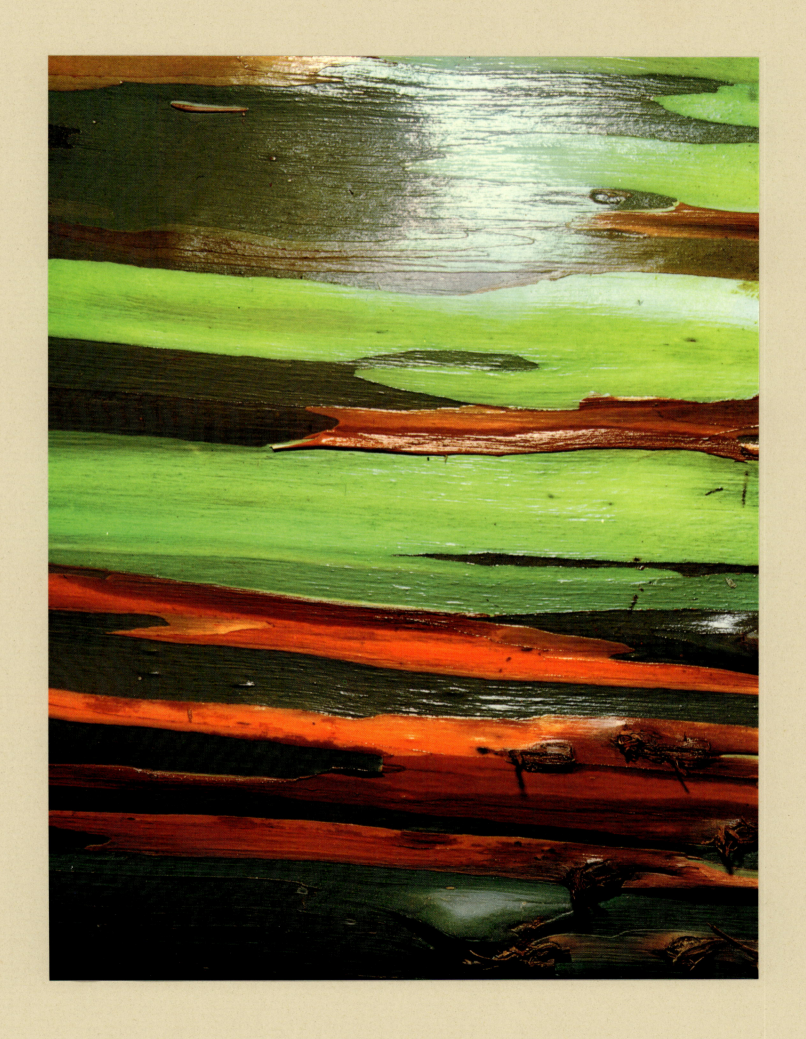

Musa paradisiaca

Banana tree. Kandy district, Ceylon.

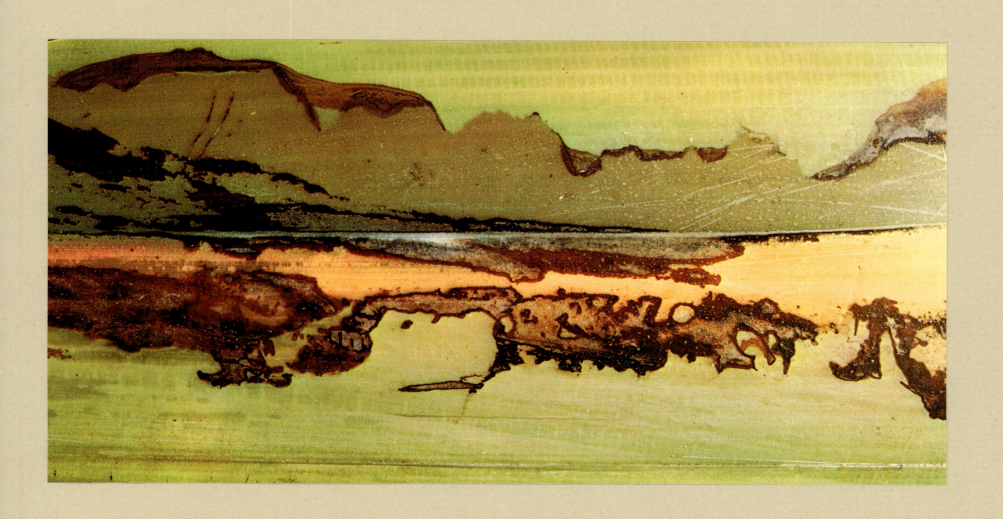

Fagus silvatica

Cross-section of common beech. Jura mountains, Switzerland.

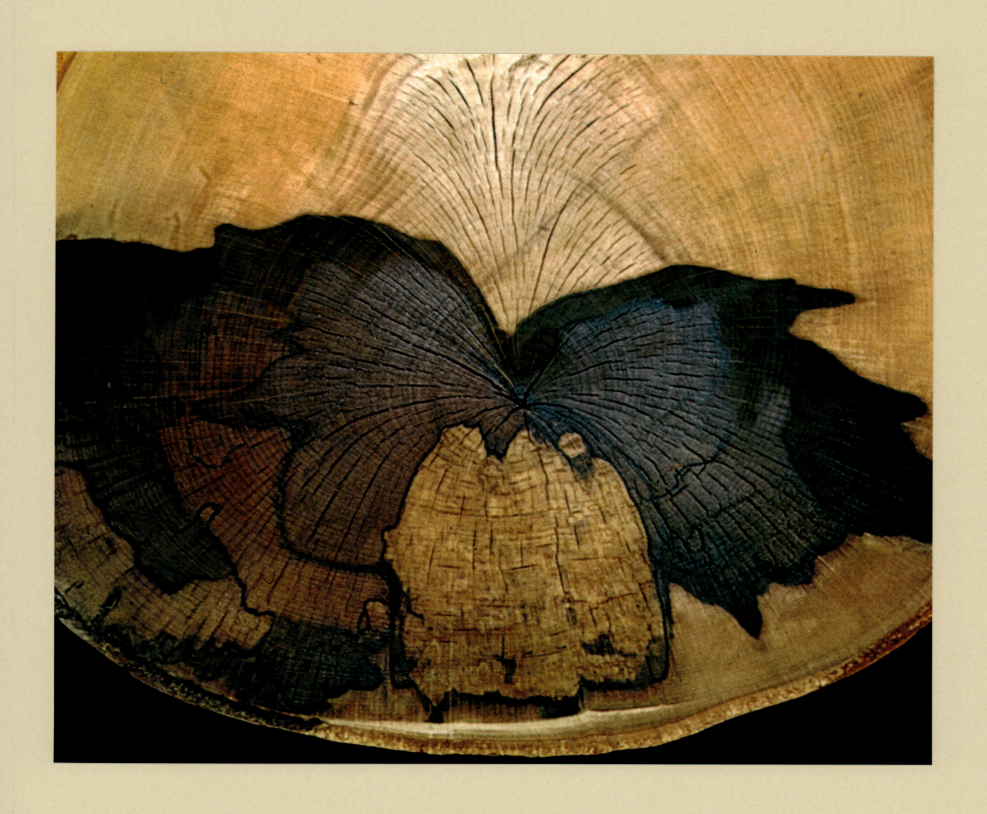

Betula alba

Common birch. Lake region of Finland.

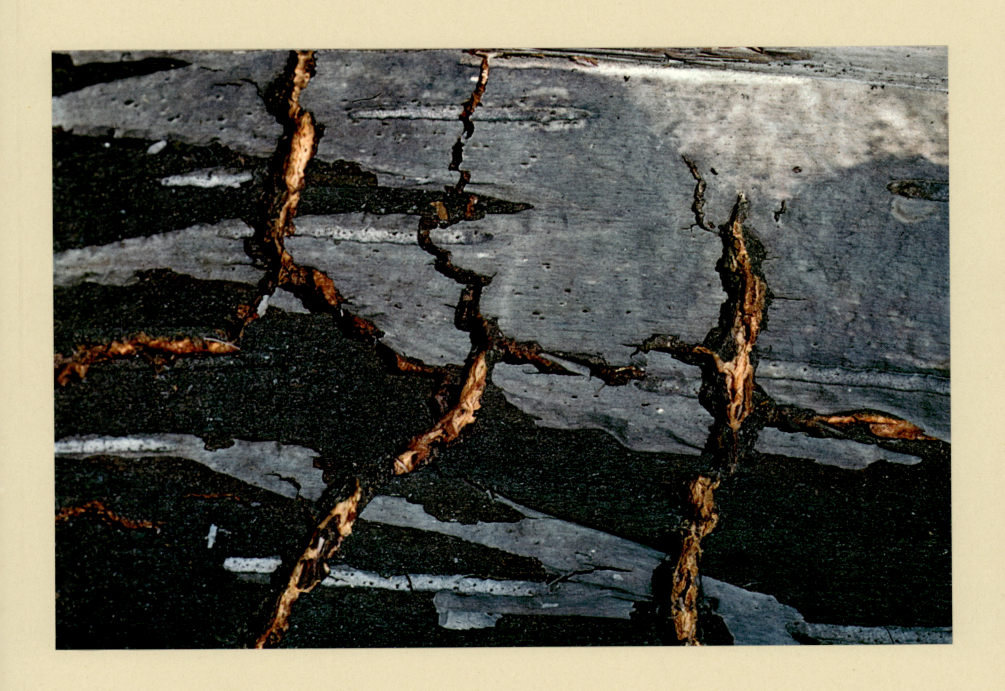

Euphorbia ingens

Giant spurge. Natal, South Africa.

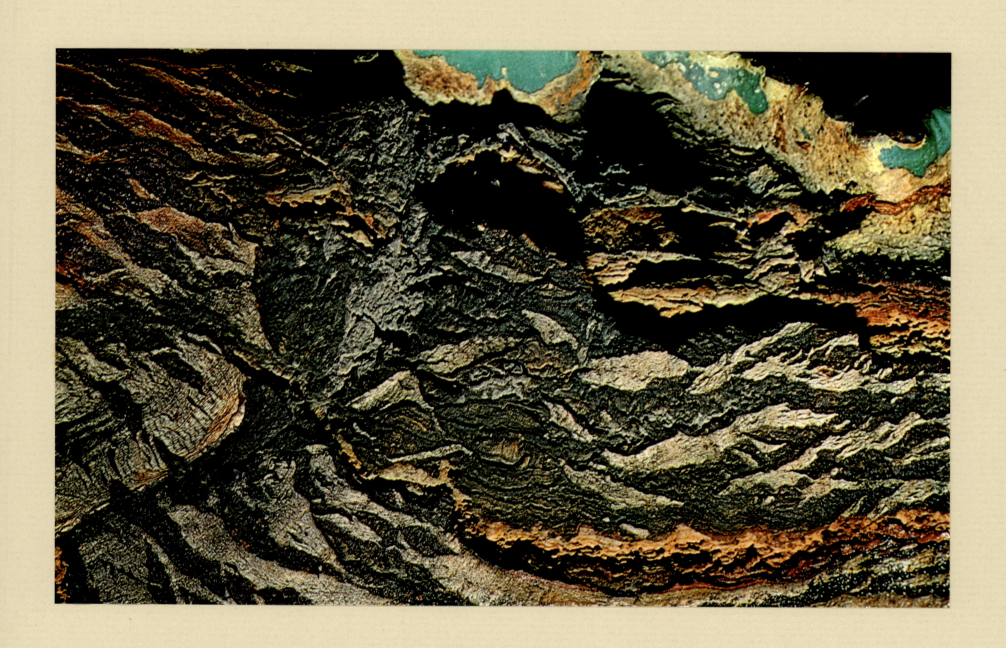

Musa paradisiaca

Banana tree - Stripped bark. Locarno, Switzerland.

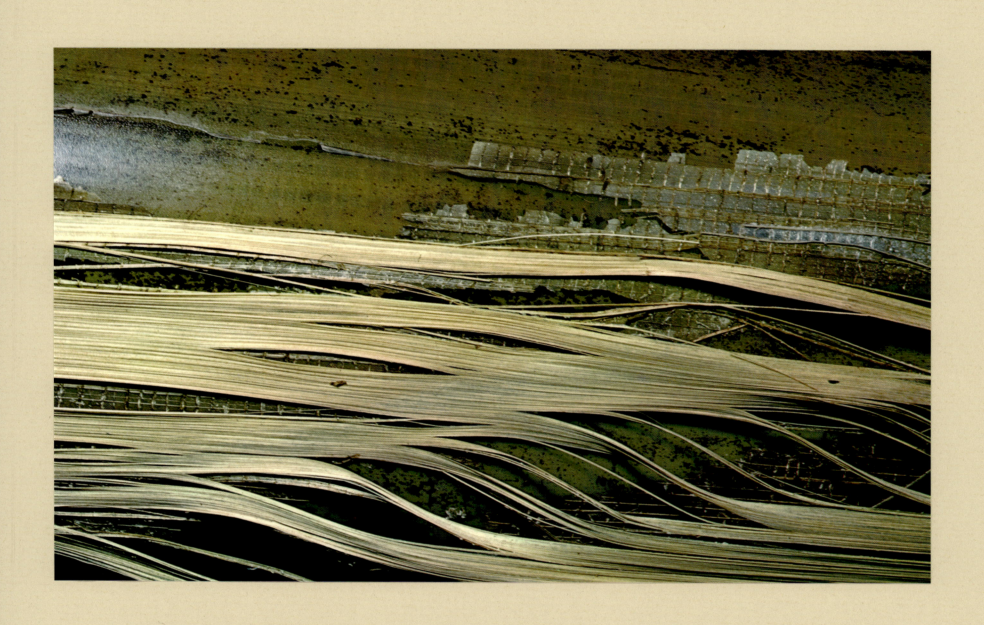

Myrtillocactus geometrisans, fam. cristata

Cactus of cristata family. Mexico.

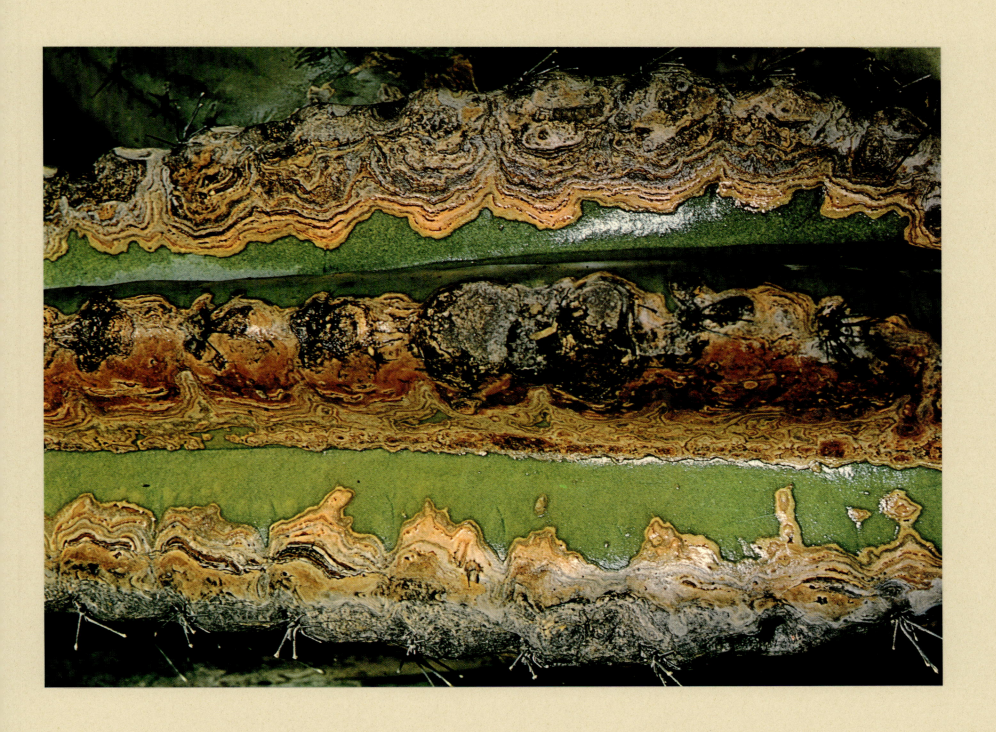

Livistona chinensis

Chinese palm. Cap Ferrat, France.

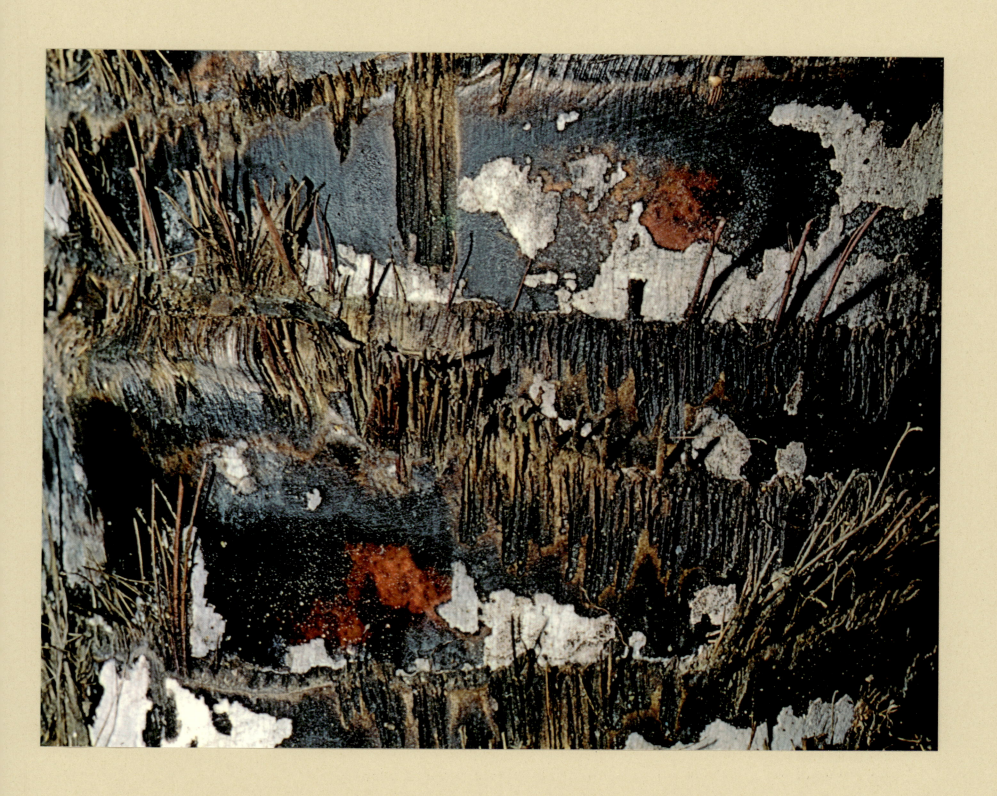

Betula alba

Common birch - Internal surface of bark. Iyväskylä region, Finland.

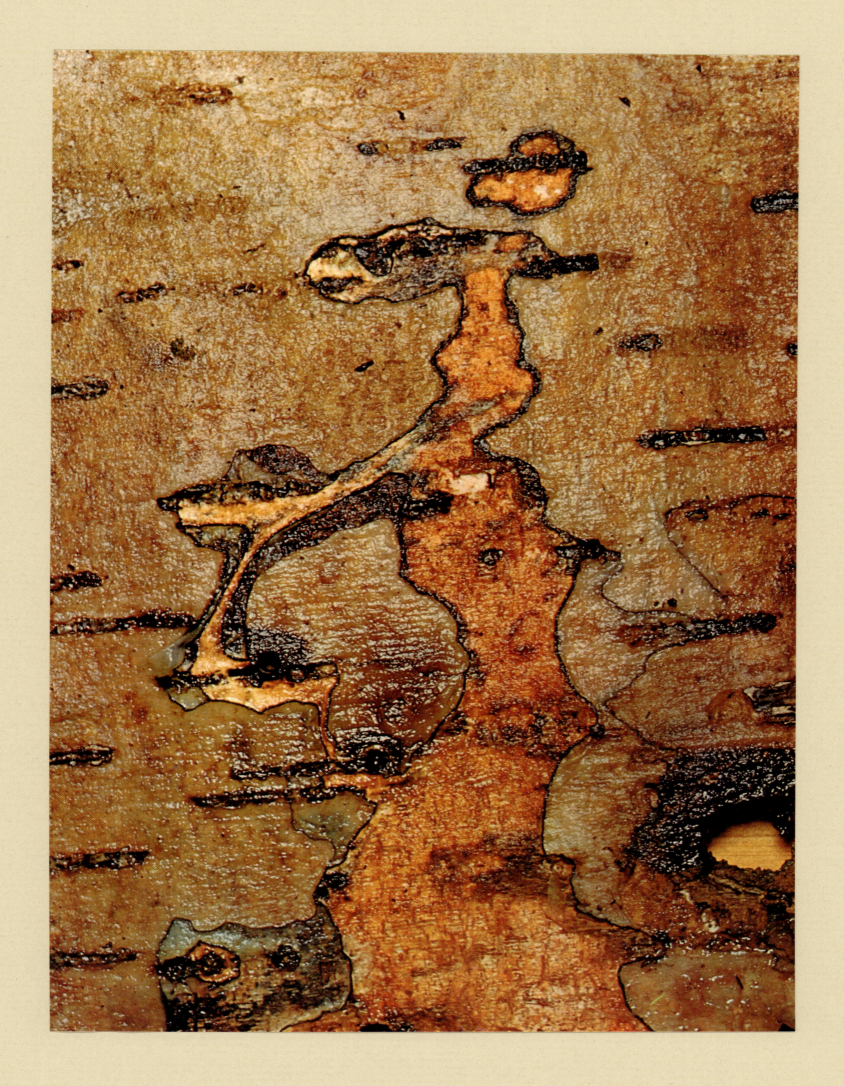

Bambus

Bamboo - Damaged foliar sheath. Majorel garden, Marrakesh, Morocco.

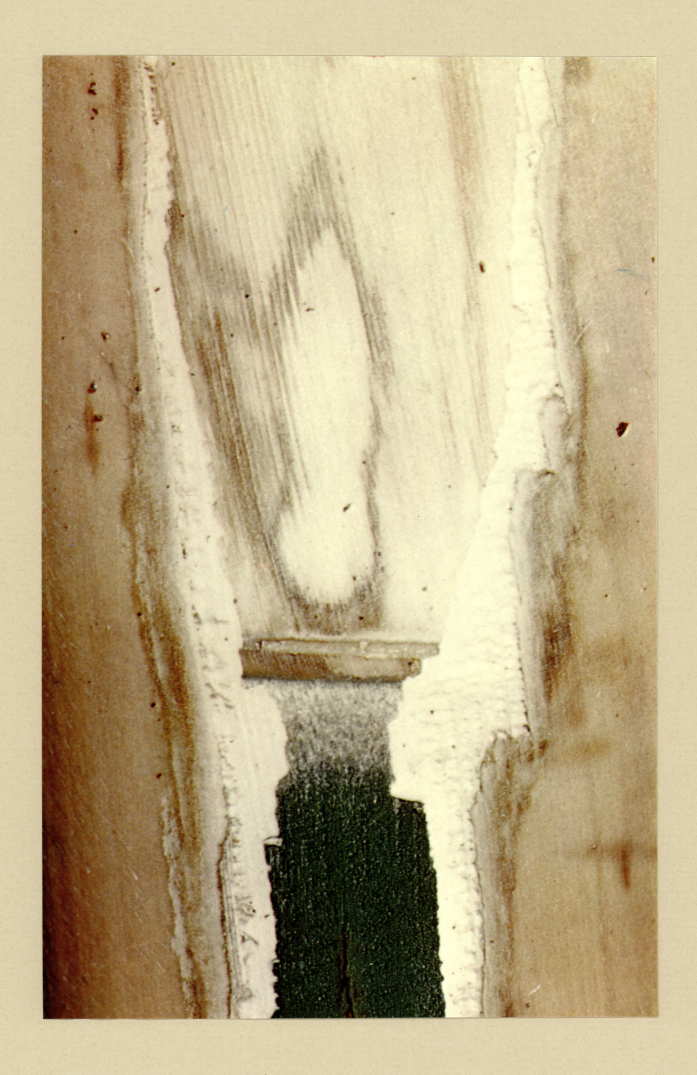

103

Fagus silvatica atropurpurea

Purple beech. Saint-Prex, Switzerland.

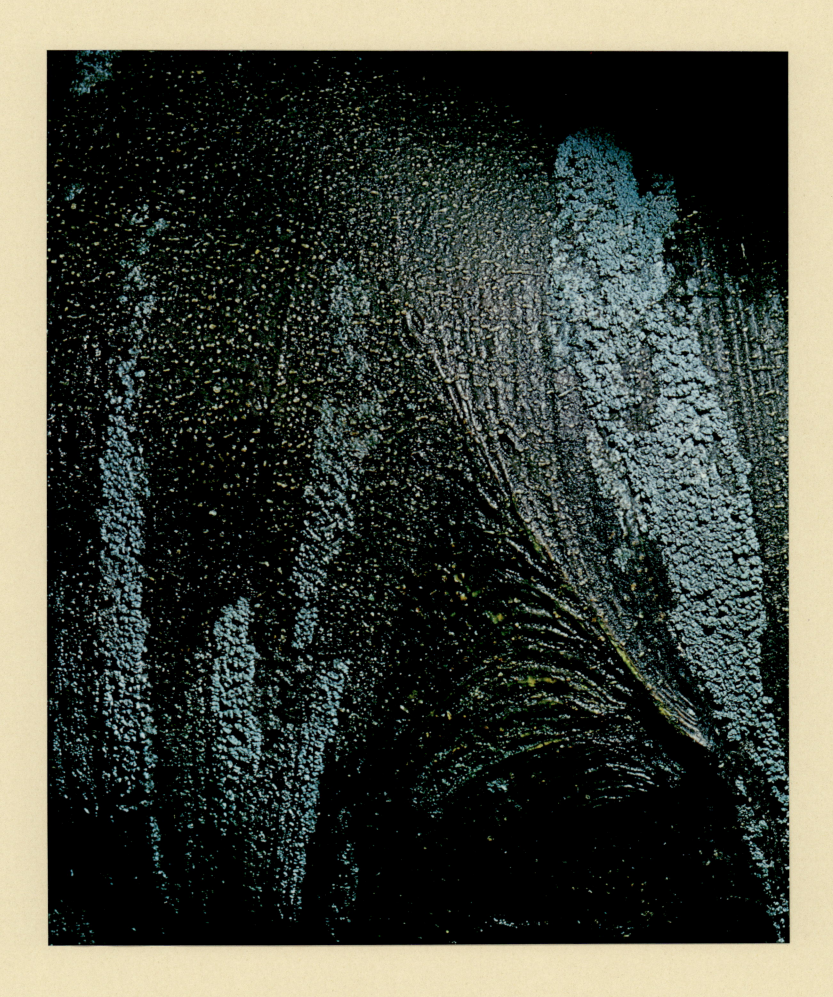

Eucalyptus

Gum tree. North Africa.

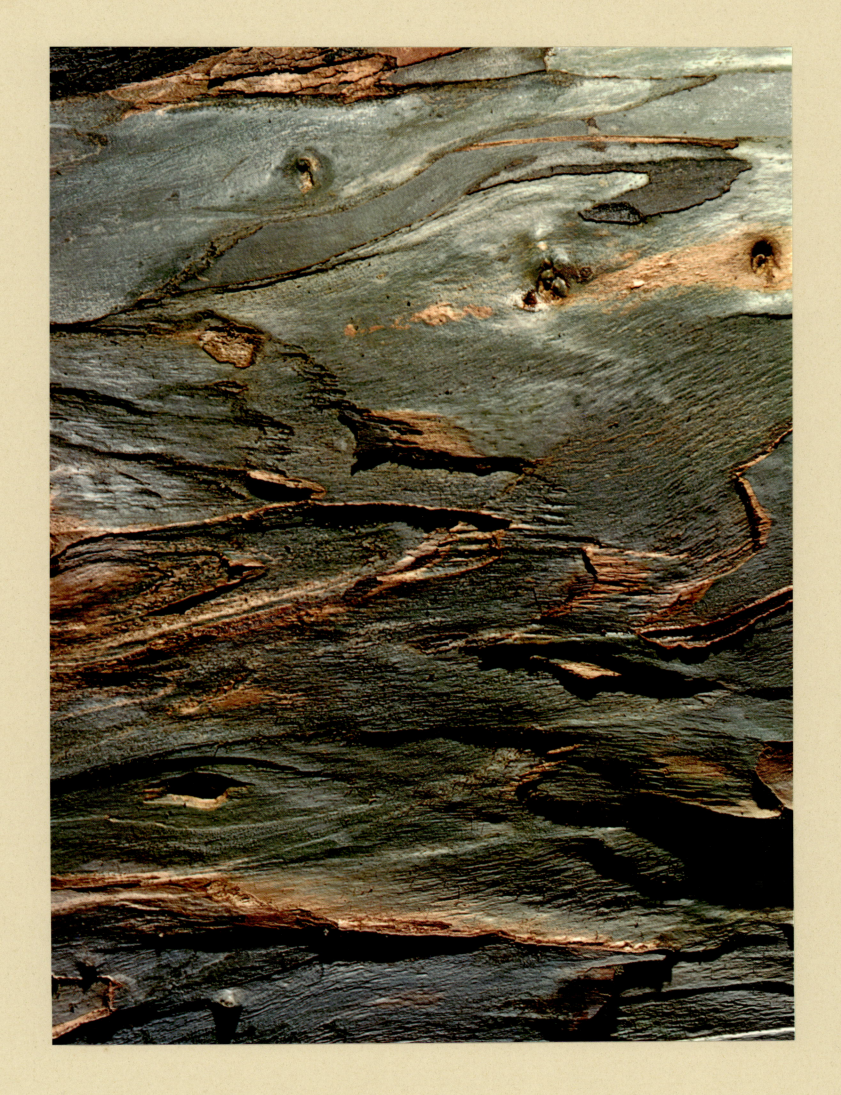

Livistona chinensis

Chinese palm. Cap Ferrat, France.

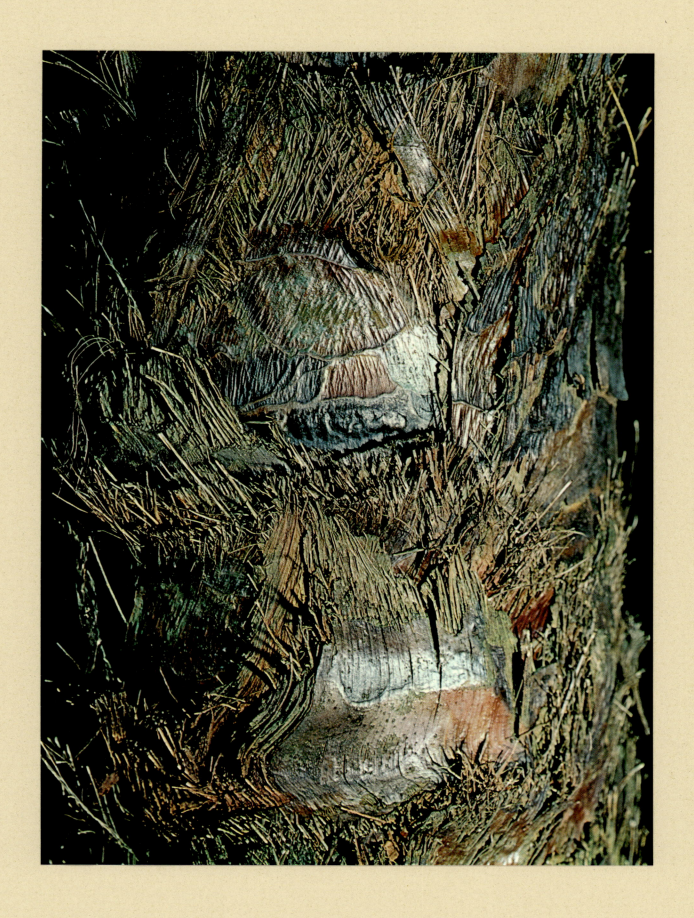

Musa paradisiaca

Banana tree. Jamaica.

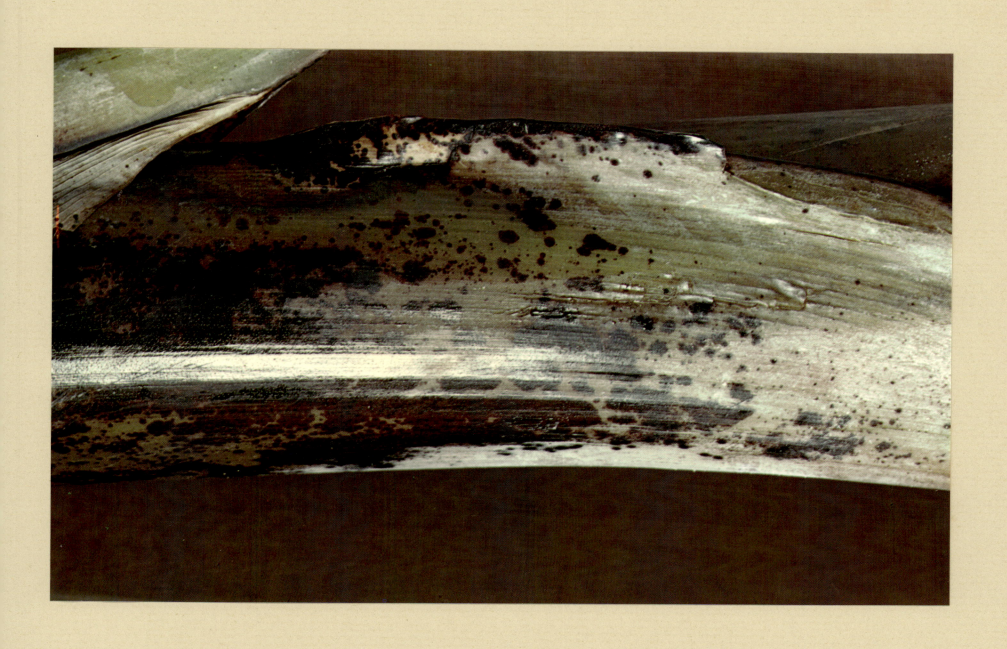

Fraxinus

Ash - Bark covered with crustaceous lichen. Jamaica.

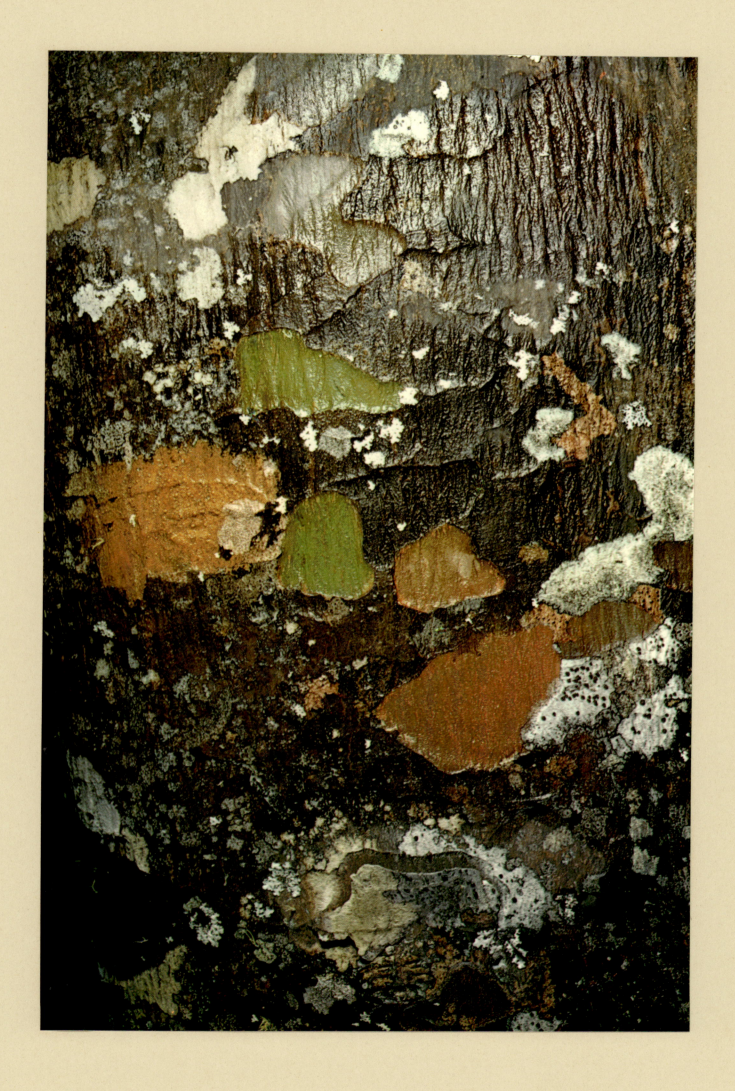

Fagus silvatica

Common beech - Excremental marks of wood-worm edged with dark trails, showing the biochemical reaction of bark to uric acid. Foothills of Jura mountains, Switzerland.

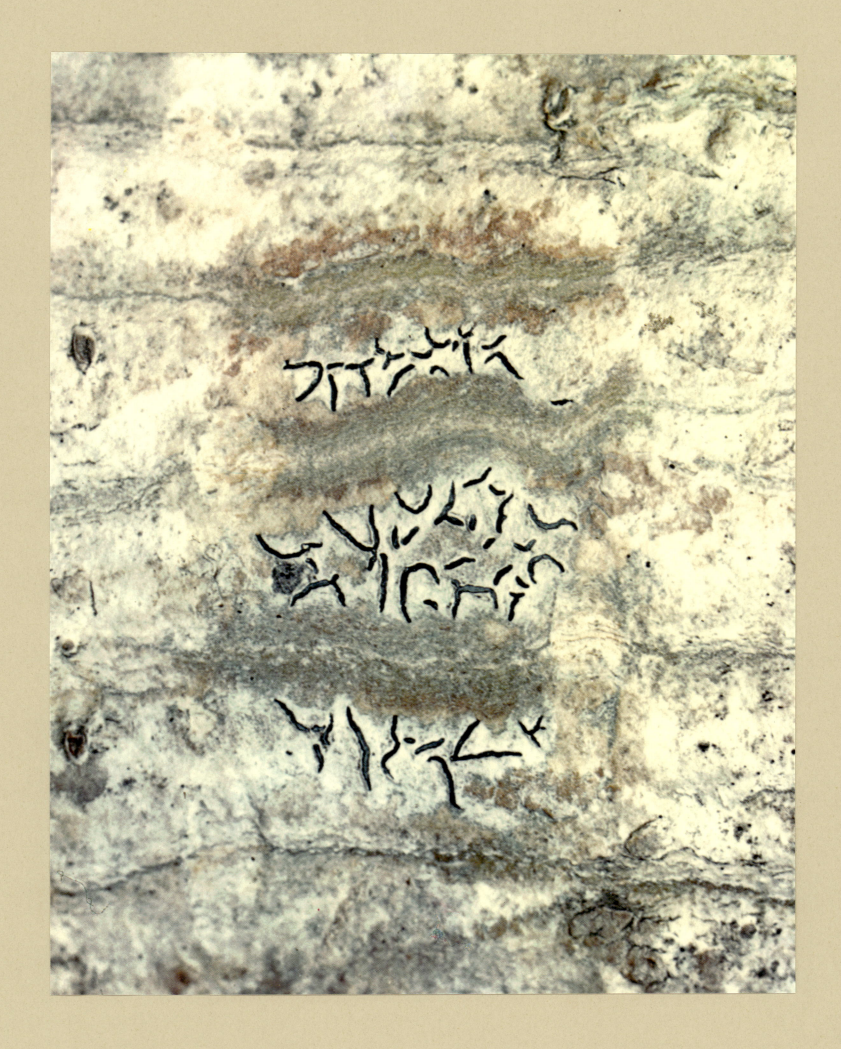

115

Cocos nucifera

Coco-nut palm - Over-ripe husk of fruit. Jamaica.

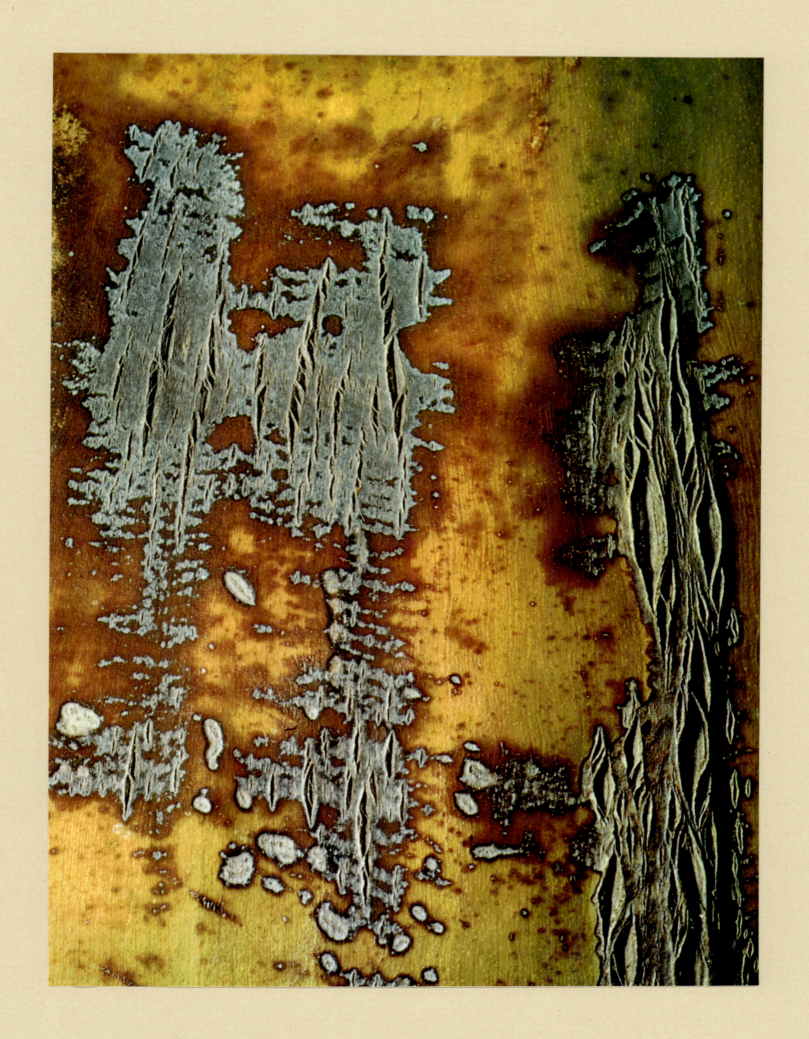

Populus alba

White poplar. Saint-Prex, Switzerland.

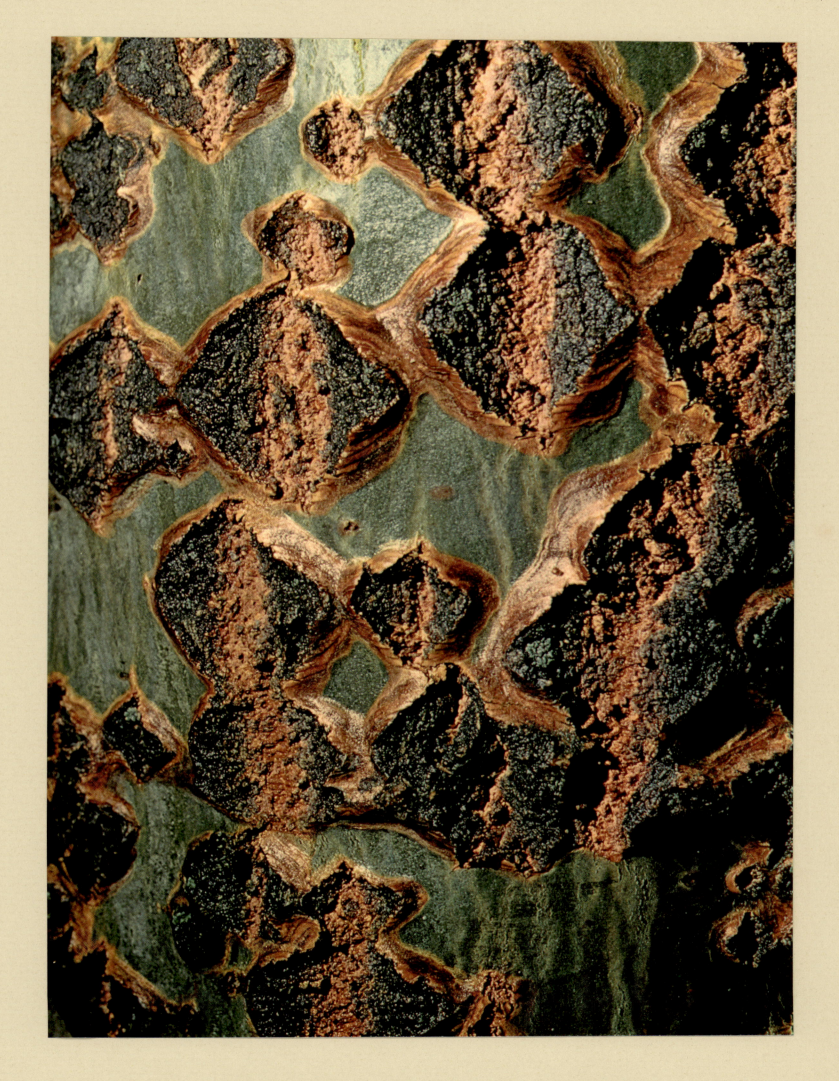

Cocos nucifera

Coco-nut palm - Leaf scars. North Africa.

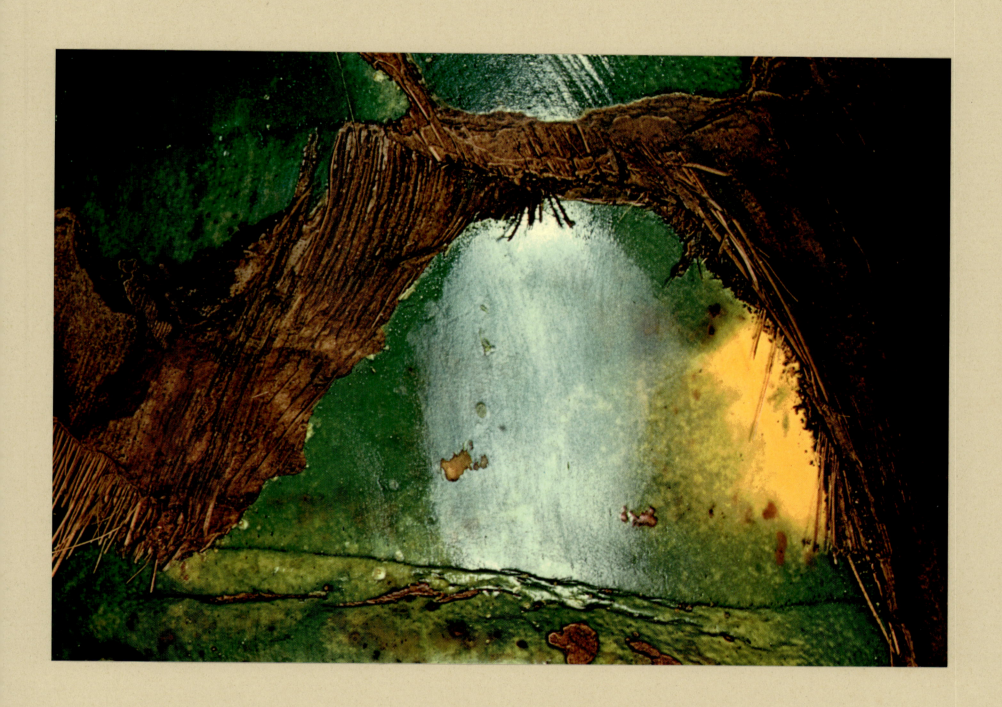

Alsophila cooperi

Giant fern or bracken. Australia.

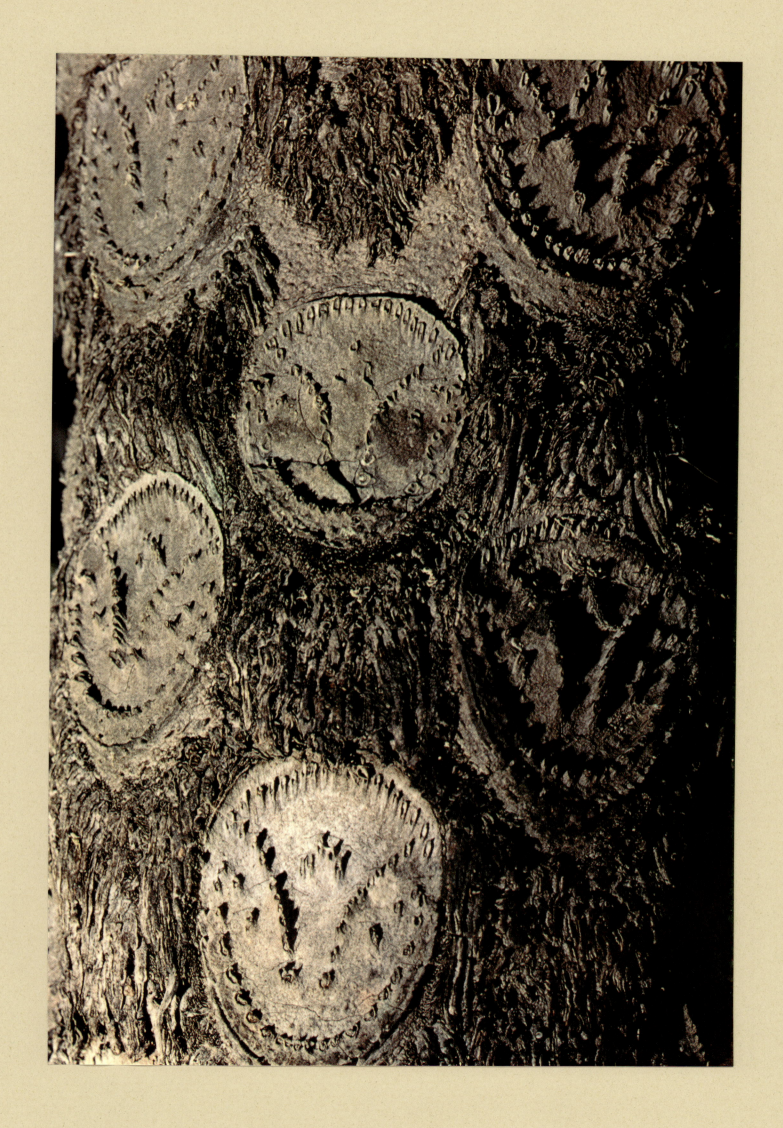

123

Aloe arborescens, var. pachythyrsa

Tree aloe. Natal, South Africa.

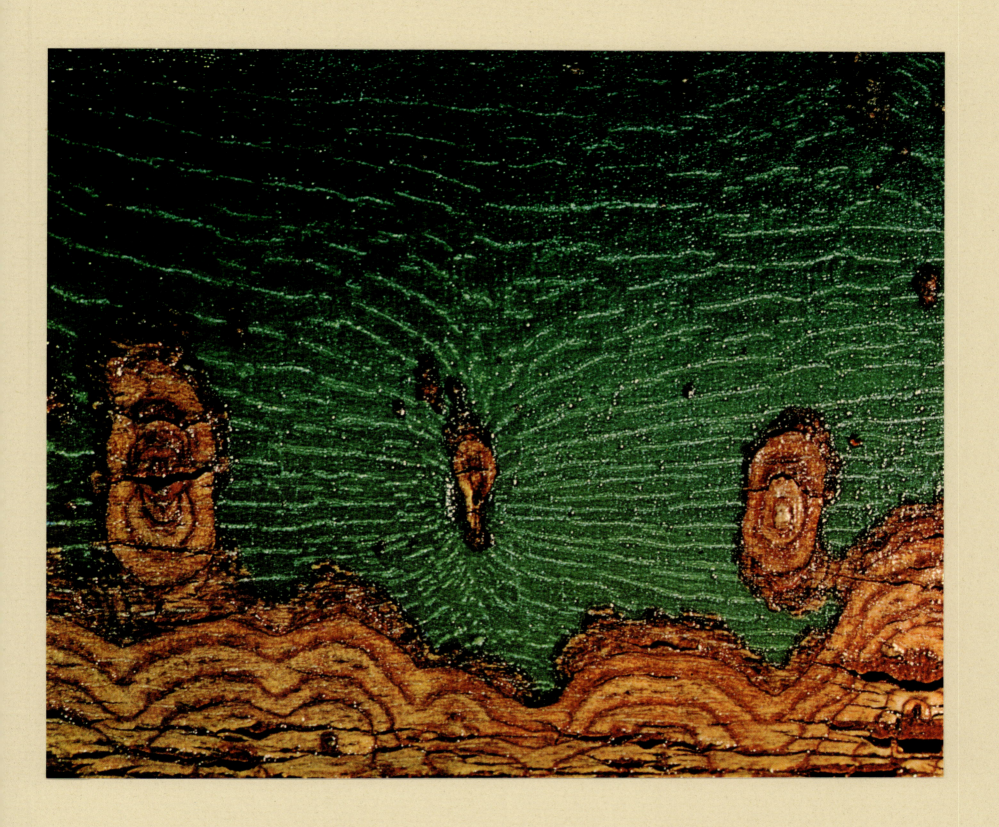

This work was edited and produced by
Edita S.A., Lausanne.

Printed by Presses Centrales Lausanne S.A.,
the photolithography was by Actual S.A., Bienne,
and the binding by Maurice Busenhart, Lausanne.

Printed in Switzerland